THE OLIVE TREE
Around the world

Photographs by **Eduardo Mencos Valdés** and text by **Charles Quest-Ritson**

EDICIONES EL VISO

La Nave Va. Garden designed by Eduardo Mencos
in praise of the olive tree, Berrocalejo, Cáceres (Spain)

Olive tree garden designed by Eduardo Mencos.
Jarandilla de la Vera, Cáceres (Spain)

Dedicated with gratitude to my wife, Anneli Bojstad,
who while watching over the mill and the homestead lovingly
allowed me to make this long journey around the world.

Like a gnarled old olive tree, I have seen myself age during my long journey in search of the different countenances of this eternal tree. However, the odyssey has turned out to be far more vibrant, surprising and dazzling than I ever imagined it would be some fifteen years ago, when the seeds of this project were sown.

It was on the other side of the world from Spain, in Australia – on meeting my future fellow travelling companion, Charles Quest-Ritson – that the idea of going on a trip around the world like Jules Verne began to take shape, but with the olive tree playing the leading role. It would be *Around the World in an Olive Tree* (but instead of 80 days it ended up as 5,600, and counting...). We wanted to tell the stories, reveal the facets and recount the vicissitudes of this emblematic tree. In our Spanish-British alliance, developed through his words and my lens, we would make an in-depth study of the olive tree; a tree that, despite being so familiar to us all, remains so much of a mystery both in terms of its diverse manifestations and the places where it grows. It would also be the history of humankind told through a tree and its fruit.

I could not have wished for a better travelling companion than Charles; he is cultured, wise, rigorous and an official olive oil taster to boot. He is typically English in that he has a romantic dreamer's notion about the Mediterranean. Whereas in my case, having been born in a country inhabited by more than three hundred million olive trees, the olive tree was always present in the landscapes of my childhood.

I am very grateful to this embattled tree, which over the years has become a touchstone for me to turn to; I have even come to view it as a virtuous and faithful friend, of the kind that is always by your side. In times of hardship, when the fields are barren and difficulties mount up, the olive tree is still there, offering up the gift of its fruit. When I hit sad times in my life, I decided to swap the psychologist for the sympathetic embrace I felt when getting to know olive trees, olive groves and olive growers all over the world, and their

warmth and love helped me through such episodes. As US President Thomas Jefferson wrote in 1787: "The olive tree is surely the richest gift of Heaven."

I look at those expressive olive trees that are hundreds or thousands of years old with admiration, seeing in their longevity the triumph of resistance in the face of adversity over time. Their shapes and barks are wrinkled faces, bearing witness to all they have lived through.

In recent decades, many illustrious elderly olive trees have been gradually replaced by other nondescript but more productive and profitable specimens, planted in super-intensive groves. You could call it fast food. Although I have also met several admirable Don Quixotes fighting to defend these venerable veterans and share their admiration for them by turning them into monuments for tourists to visit. I look deep into the eyes of these ancient olive trees so that they can tell me about their life, imagining the Roman or the friar missionary who planted them, with that breath of hope for the future that planting a tree always brings with it. As a landscape designer, I express my devout passion for the olive tree by enhancing the beauty of the gardens I make with its majestic presence.

This lengthy journey has also been an excuse for me to travel with each of my three children, riding in the car together, in that private space for intimate conversations, without any distracting screens to get in our way as we threw ourselves into the hunt for olive trees in the remotest of places.

None of my trips ever disappointed me. Each and every country I visited rewarded me with some unique feature unknown to olive growers in other parts of the world. In Ethiopia, the huge olive trees, rising to a height of 20 metres, marking the location of their churches, with parishioners brushing their teeth with the trees' branches. In South Africa, Zulu women combing and milking olive trees, picking each olive one by one.

In the world's most quintessential desert, the Atacama in Peru, in lands where there has been no rain for four hundred years, I discovered olive trees. In the Tacna region – despite being so close to the equator – they grow thanks to the 'panza de burro', the almost permanent low cloud that keeps temperatures mild while the soil drinks in the water that runs down from the Andes. These are olive trees that have never seen a drop of rain fall from the sky, and yet they still manage to produce large, tasty olives.

In Egypt, I visited new plantations in the middle of the Sahara, irrigated with fossil water that is millions of years old. Fossil water deposits, hundreds of metres deep, also feed the huge, ultramodern olive groves that are taking over the Saudi Arabian desert.

The old cliché of the olive tree as a Mediterranean tree dies a death in China, where they have successfully planted olive groves in monsoon climates, irrigated by summer rainfall. They pull off all sorts of feats there; some of their olive trees are even planted on impossible vertical walls. They have also created cities like Longnan, given over completely to the olive tree and its infinite facets, with futuristic olive mills that look like spaceships, streets with olive-shaped lamp posts and luxurious shops stocked with all kinds of items derived from the olive tree, ranging from herbal teas to beauty products.

And then there is Mexico. In Baja California I came across a three-hundred-year-old youngster of portentous size and cephalopod-like appearance – a real monster of a tree. The nearby irrigation ditch had turned it into the biggest olive tree I have ever seen. If only the Jesuit who planted it could see his little baby now....

In Albania, I came across another 2,500-year-old giant, that had surely watched Alexander the Great's army go marching by. Like a living temple, it could hold up to thirty people inside.

If for northern Europeans the olive tree embodies the dream of the Mediterranean sun, for farmers in that part of the world it is their livelihood. It is the lifeblood, watered by their sweat and tears. It is also hope: the olive branch brought to Noah by the dove heralded the end of the Flood and the start of a new partnership between God and humankind. It is the universal symbol of peace.

I would like to awaken a vision of the olive tree that is imbued with beauty, poetry and curiosity, as the protagonist not only of agri-culture but of culture in all its myriad facets.

I hope that this book will be like a caravel for curious minds, a sailing ship carrying us away towards a never-ending horizon where new discoveries await us. The sailor in me is grateful to Goya Foods, whose sponsorship has given us these recent favourable winds and encouragement for us to set sail at long last.

Bon voyage, my friends.

Eduardo Mencos Valdés

Contents

Introduction

The Origin of Species

Olives are cultivated selections of a spiky, spiny shrub or small tree known to botanists as *Olea europaea* L. The wild species originated somewhere in the Middle East and is probably extinct. Its place has been taken by cultivated forms with names like Frantoio and Picual, and by seedlings known as oleasters. Nevertheless, there is vigorous competition among nations to claim the original wild olive as theirs. Turkey, Syria and Israel are among the states asserting that such an important plant must surely be native to their country and to no other.

Palaeobotanists who have studied fossilised olive plants tell us that the olive tree originated 20-40 million years ago, somewhere in the Oligocene region that later became the Mediterranean Basin. More recent evidence comes from fossilised leaves found in the soil and rock of Santorini, which have been dated to about 37,000 BC. The leaves had been infected by larvae of the olive whitefly, *Aleurolobus olivinus*, which is still a pest today – though one might also say that its presence is a nice example of co-evolution over the millennia.

Time leaves its mark. Ancient olive tree in Teos, Ionia (Turkey).

The genus *Olea* has some 35 species. Most are native to tropical regions, and some are tall trees: *O. rubrovenia* from Borneo and *O. capensis* from East Africa will reach 30 metres in height. *Olea europaea* is the only species that produces edible fruit, which makes it the ancestor of all cultivated olives.

Botanists approach *Olea europaea* – the Mediterranean olive – with their customary tendency either to split the genus into innumerable subspecies or to lump all variations together under the accepted name of *Olea europaea*. Lumpers generally maintain that there are five or six subspecies, while splitters project some thirty or more. Most widely accepted now is the revision of the genus published in 2002 by Kew botanist Peter Shaw Green, who considered that *Olea europaea* has six subspecies. Of those, most important is *O. europaea* subsp. *europaea*, which includes wild types or oleasters (var. *sylvestris*) and the domesticated olive (var. *europaea*).

Another important subspecies is *O. e.* subsp. *cuspidata*, sometimes known as *Olea cuspidata* or *Olea africana*, which has a very wide natural distribution, from South Africa to south-eastern Egypt and from the Middle East to India and China. This is a handsome, multibranched evergreen tree growing up to 15 m in height and valued everywhere for its hard, durable wood. It bears clusters of olives – rather small (1½-2½ cm) and too bitter for human consumption – but attractive to birds whose digestive tracts absorb the flesh but expel the stones and spread them around, ready for germination.

Rarest of the olive subspecies is *O. e.* subsp. *laperrinei*, which comes from the mountains of the south Sahara, where it survives as a relic of pre-desertification. It exists at high altitudes in three disconnected sites: the Hoggar Mountains in southern Algeria, the Aïr plateau in Niger and the Jebel Marra Mountains in the Darfur region of Sudan. It has played a part in the evolution of *O. europaea* subsp. *europaea*, but is not cultivated for its fruit. However, tourism experts believe that it may have value for the development of eco-travel in the remote localities where it survives.

O. e. subsp. *maroccana* comes from southwestern Morocco, in the Atlas Mountains behind Agadir. It intrigues botanists because the olives have three times the usual volume of chromosomes – they are hexaploid whereas Mediterranean olives are diploid. Polyploidism is evolution's way of surviving and developing. It is a genetic response to stress, common among isolated populations of many plants, and it avoids the danger of inbreeding. But recent research has shown that *O. e.* subsp. *maroccana* developed not from the 'common' Mediterranean oleaster but from *O. e.* subsp. *laperrinei* – which makes it of even greater interest to botanists.

O. e. subsp. *cerasiformis* in Madeira also carries more genes than usual, because it is tetraploid and has twice as many chromosomes as the Mediterranean olive from which descend all the varieties we eat or press for their oil. The emergence of tetraploidy is not unusual in isolated populations but botanists have discovered that it is actually a cross between the 'ordinary' Mediterranean olive and the Moroccan subspecies. One of its four sets of chromosomes came from subsp. *europaea* and three from ssp. *maroccana*.

The sixth subspecies of olive comes from the Canary Islands and is known as *O. e.* subsp. *guanchica*. It is closest botanically to *Olea europaea* and probably represents an east-to-west expansion of the species. Put simply, it probably developed from seeds deposited by the autumn migration of birds from the Mediterranean region.

Cultivated olive trees are slow-growing, long-lived trees, usually no more than 8 m high, though some cultivars will reach as much as 20 m if untended. They have short, thick trunks that become gnarled and ragged as they mature, and they branch freely, making a thick crown whose size and shape depends largely on how they are trained and pruned. Plants that are grown from seed form a deep taproot that searches out water, but many cultivated varieties are grown from cuttings which have a more fibrous root system.

Olive trees have persistent foliage, usually green on top and pale grey or white on the undersides. The leaves are simple and lanceolate up to 10 cm long (usually less) and 1.5 cm wide, arranged in opposite decussate pairs, which means that they are held at right angles to the pair of leaves above and below. The flowers are very small, white, and borne in small clusters on last year's new wood. Olive trees are wind-pollinated, so the anthers are generously loaded with pollen.

The olive fruit is a drupe – it has a very hard stone surrounded by edible pulp known as the mesocarp. The skin is usually green, but in autumn it turns slowly to mottled shades of red-brown, purple and black. Olive fruits vary greatly in size; those borne by the wild species were very small.

The Domestication of the Olive

Olives, figs, vines and date palms were the first fruit trees to be domesticated. And the fact that grazing animals ate olives may have given humans the idea of developing them for their own consumption.

Several states in the Middle East today have claimed the glory of being the *locus classicus* of olive-growing. A collection of stones that were larger than those of wild olives was found at Teleilat Ghassul in Jordan and dated to 3,700 BC. And thousands of crushed olive stones, mixed in with pulp, at the submerged Kfar Samir archaeological site near Haifa suggest that olive oil was known by about 4,500 BC.

When the DNA of these ancient remains was extracted, they were found to share some of their genes with modern varieties from France, Spain and Italy. But recent tests have concentrated on dating the ancient olive pollen preserved in Mediterranean lakes. A sudden increase in pollen would indicate that olives were under cultivation for the first time. The earliest records of a surge of olive pollen dates to the Dead Sea (c.4,500 BC) and the Sea of Galilee (c.5,000 BC), so it is probably there – in the southern Levant – that olives trees were first domesticated.

Domestication began with the selection and propagation of individual plants that showed some advantage over the others. The first efforts at stabilising and multiplying desirable characteristics probably involved no more than sowing their seeds. Since the olive was a small, spiny shrub, it is not surprising that it was developed to become a thornless tree. But our ancestors also needed to understand the principles and practice of vegetative propagation. For olive trees, that meant the ability to graft desirable scions or to take cuttings and treat them in such a way that they made roots and grew away as duplicate trees. Vines and figs can easily be grown from cuttings, and both were being propagated from about 4,500 BC, so we may conclude that the same knowledge was applied to selected olive trees.

The first olive cultivars were trees selected for their usefulness, probably because they had larger fruits than wild olives. Cultivar is botanic speak for a cultivated variety. The word is used to describe plants that have been selected and propagated because they are perceived to be an improvement on the species to which they belong. It is unlikely that any of the first olive cultivars still exist, but it is certain that they, in turn, gave rise to seedlings that exhibited further improvements. These offspring would then be propagated so that they were represented in cultivation by more than one identical plant, at which point it would be fair to call them cultivars.

Cultivated olive trees spread eastwards to Iran, Pakistan and China, across the North African coast via Egypt to Tunisia and Morocco, and along the Mediterranean coast of Turkey to the Aegean Islands, Greece, Italy, Spain and Portugal. As olive-growing spread across the Mediterranean Basin, the process of tree-selection continued. Local wild olives, which are interfertile with cultivated olives, played a part in this process of diversification. Scientists have traced the historical development of olive cultivars by comparing their DNA to discover what they have in common. They have now established that the earliest cultivars were selected for the size of their olives, because two of them turn up in the distant ancestry of almost all others. We know them as Safrawi and Gordal Sevillana and, despite their current names, both originated in the Near East and were spread throughout the Mediterranean by Phoenician traders and settlers in the period 1,000-800 BC.

**Olive trees and fighting bulls,
Carmona, Seville (Spain)**

The fruits of Safrawi and Gordal Sevillana may be as much as 4½ cm long and 2½ cm wide, but size is not the only reason for selecting a seedling olive-tree and propagating it. It may be hardier, more resistant to drought, easier to cultivate or heavier cropping; these, and many others, are the reasons why cultivars emerge as varieties that are superior and therefore worth multiplication. Domestication has created a range of productive and adaptable trees. There are at least 2,000 cultivars grown worldwide, although the International Olive Council (IOC) estimated in 2021 that 85% of the world's olive trees were accounted for by 139 varieties, cultivated in 23 different countries. And olive domestication is still an ongoing process.

The earliest hybrids that arose in those parts of the Mediterranean to which Safrawi and Gordal Sevillana were introduced – for example, in Italy and Spain – came from natural crosses that these two distinguished cultivars made, either with wild olive trees or with other selections. The olives were consumed and dispersed by birds, then germinated and grew to become trees. Such seedlings are known as *olivastri* in Italian, *acebuches* in Spanish and simply as *oliviers sauvages* in French. They are present wherever olive trees are grown and are usually treated either as elements of the natural flora or as 'weeds' that need to be removed.

Oleasters, cultivated olives and the wild species are fully interfertile. A high proportion of oleasters are the result of outcrossing. And even those oleasters that result from the self-pollination of economic cultivars are different from their parents because the process of meiosis ensures an almost endless re-combination of the available genes. In fact, oleasters are seldom as good as the varieties of which they are seedlings. Whatever the genus, it is rare for seedlings of selected cultivars to display to a high degree the qualities of their parents – the qualities that defined those cultivars in the first place and rendered them worthy of further propagation and cultivation. From time to time, however, one will appear that is seen to promise an improvement on existing cultivars and will then be preserved and propagated, perhaps on such a scale that it will eventually become one of the dominant varieties in its area or beyond. Indeed, many locally cultivated olive trees are the result of strong introgression by local oleaster populations or their local domesticated derivatives.

In many other parts of the world, however, olive trees are an invasive exotic species and a major threat to biodiversity. They compete with the native flora and interrupt the functioning of the ecosystem. In South Australia, their seeds are spread by the red fox (a European introduction) and by many bird species, including the European starling and the native emu. Oleasters germinate readily and eventually form a dense canopy that prevents the regeneration of native trees. There is no means of preventing this apart from strict laws to govern the transport and planting of aggressive species. Oleasters are no different from other creatures: their principal biological purpose is to perpetuate themselves.

The Development of Cultivars

The domestication of the olive has not reduced its genetic diversity, Oleasters continue to exhibit a high degree of genetic diversity. They may not be good enough to be selected as trees worthy of cultivation, but they may display greater vigour, greater yields or resistance to such diseases as Verticillium wilt. Other positive traits have been found to include increased flower production, better quality oil and resistance to soil-borne diseases. Scientists refer to 'active farmer selection'.

Generations have propagated varieties that are the most adapted to their particular growing conditions. Puglia's Cipressino, for example, is noted for its resistance to salt-laden wind. The super-Tuscan Maurino and Leccino are grown for their resistance to cold in the uplands of Siena and Florence and for their ability to

ripen fruit within the short growing season that prevails in such conditions. Tunisia's Chemlali has a vast root system that enables the tree to access enough water to survive on the edge of the Sahara; it may be planted with as few as four trees to the hectare, but no other plant of economic importance will survive so close to the limits of the desert. Another important characteristic that differs between cultivars is the requirement for a period of comparatively cold weather for the initiation of flowers and thus for the production of olives. It has been suggested that *Olea europaea* var. *africana* may have contributed to the emergence of cultivars in Egypt and Tunisia that do not need a period of cold winter weather to set viable pollen.

Olives are often self-sterile. Cultivated varieties like the Leccino, Maurino and Moraiolo from Tuscany will not set fruit with their own pollen, but they are strong and reliable pollinators for each other and for other varieties. Even varieties that are considered sufficiently self-fertile for commercial purposes will often give larger yields if they are pollinated by a different cultivar.

Many of the well-established and widely-grown olive cultivars are very old. It is thought that the Tuscan olive Moraiolo dates back to the Roman Empire. Some say that Pisciottana from the Cilento – one of the tallest olive trees, capable of reaching 18 m in height – is another olive of Phoenician origin. And the ancient tree in Villamassargia, Sardinia, known as 'Sa Reina' and estimated to be around 2,000 years old has been identified as the cultivar 'Pizz'e Carroga', still one of the mainstays of olive-growing in the south of the island.

However, in every traditional area where olives are grown there are also minor cultivars whose existence is very local indeed. They may be previously popular cultivars that have been superseded by better ones. And, although they may exist only in very small numbers, their DNA may still hold useful attributes for future breeding. Some may have been planted not for their olives but because they were good pollinators for self-sterile cultivars. Many have been gathered together in national and international collections under the auspices of the International Olive Council.

Selecting the Best Cultivars

Until modern times, very little comparison was made between the olive cultivars that grew in different places. They were just the varieties that had been selected by generations of growers as most suitable for their particular area and could therefore be assumed to be the best. Some had emerged as good for table olives and others gave

a good yield of oil, though dual-purpose cultivars are also widely grown. Usually, more than one cultivar would be planted because most olives crop more heavily if they are cross-pollinated by a different variety.

Countries like Greece, Italy, Portugal, Spain, Tunisia and Turkey have been growing olives for thousands of years. Some cultivars are very adaptable and can be grown successfully in a wide variety of climates and soils. Among the most popular are Arbequina, Leccino, Picual and Frantoio. But other varieties have arisen and been selected region by region, often village by village, and these are normally confined to their area of origin. Chemlal from Algeria is a cultivar which, even if grown very widely in its area of origin, remains almost unknown elsewhere.

Spain is the world's largest producer of olives and, although excellent olives and oil are produced in almost region, the centre of the olive industry is Andalusia. The scale of olive-growing is unparalleled. There are 156 olive cultivars of Andalusian origin, and you can see almost of all of them in the national collection at the University of Córdoba. But only seven of them are widely cultivated: Hojiblanca, Lechín de Sevilla, Manzanilla de Sevilla, Nevadillo Negro, Picudo, Picual and Verdial de Huévar. Picual accounts for 60% of the crop and Hojiblanca 20%.

There are countries where an even larger proportion of just one cultivar is grown. In Greece, Koroneiki now accounts for 60% of all olive trees. In Morocco – a heavyweight among olive-growing nations – 90% of all olives are of the Picholine Marocaine variety. These are cultivars that perform so well in their place of origin that they have, in effect, beaten off all competitors.

Careful selection over the centuries has given us olive cultivars that will grow in conditions where the wild species would not normally survive. A problem arises, however, when new pests or diseases evolve or arrive from abroad. This is most clearly seen in the province of Lecce, in the 'heel' of Italy. A bacterium – a subspecies of *Xylella fastidiosa* –is thought to have arrived on a coffee plant from Central America in 2008. Five years later, it was seen to have spread to olive trees in Lecce which had dried up, scorched and died. The search began for cultivars that showed some resistance to the bacterium using, as controls, the local varieties Cellina di Nardò and Ogliarola Salentina that were devastated by the disease. More than a hundred cultivars have been tested for resistance to *Xylella*, but only one has yet been found that is resistant – the Tuscan cultivar Leccino. Molecular biologists are now looking for hybrids of Leccino and its close relatives to see whether others might carry the gene for resistance. FS17 and Dolce Tonda have been singled out as possible candidates but it is thought that they are not actually resistant to *Xylella*, merely non-symptomatic. This means that they carry the disease but show no sign of infection and can therefore be cultivated in affected regions. However, they remain a resource for the further infection of other plants, which is not desirable.

A rooftop of olive trees in Setenil de las Bodegas, Cádiz (Spain)

In recent years, we have seen the emergence of super-cultivars that are widely grown outside their place of origin. Leccino is one of them, because it is a consistent producer of high-quality oil. And the spread of super-intensive plantings of Arbequina has brought success to several countries that had little previous experience of olive-growing. For them, the economic consequences of an infection like *Xylella* would be disastrous.

The modern system of granting PDO or PGI status to olive trees growing in a defined historic area has enshrined the importance of local cultivars as essential components of international food legislation. For example, at least 90% of the olives used for Brisighella's DOP oil (DOP is the Italian abbreviation for Protected Denomination of Origin) must come from Nostrana di Brisighella olives, a variety grown only in a few municipalities in the Province of Ravenna and Forlì-Cesena. And 50% of a Veneto Valpolicella DOP oil is composed of two very local cultivars, Grignano and Favarol. The rest may come from Leccino, if available, or from local cultivars like Trep and Dropp, which are almost unknown even to inhabitants of the communes where they grow. But it is important to remember that all these cultivars emerged as the most suitable olives for making good oil in the places from which they come.

Among the tallest olive cultivars are Sinopolese and Ottobratica, each capable of reaching 20 metres in height. They are native to Reggio di Calabria and often planted together to act as pollinators to each other. Such is their height and shape that at first sight they may be mistaken for willows or evergreen oaks. The natural height and vigour of Sinopolese and Ottobratica make them difficult to cultivate, as does their tendency to alternate-year production. Picking the olives is a problem. The old method of harvesting was to pick up the fruits that dropped off the trees, especially after a rain storm. However, that required the pickers (usually women) to collect the fallen olives many times for up to two months, which made for substandard oil. The best oils are made when the whole tree is shaken so that the olives fall into an 'inverted umbrella' that softens their landing and collects them up, ready to be sent for pressing.

Other cultivars are notably lacking in vigour. Nocellara del Belice, famed in Sicily for its large olives and richly fruity oil, is a timid grower, easily trained to a shape that enables its fruit to be picked without any need for ladders. Its small size means that it can be planted more densely than other cultivars and, since it is also a constant bearer, not much tending to biennial cropping, it is increasingly widely grown outside its place of origin on the lowland hills of south-west Sicily. The Catalan cultivar Arbosana is also very lacking in vigour, which has led it to join the closely-related Arbequina as a variety that is suitable for super-intensive plantings all over the world.

In Andalusia, a popular cultivar is Hojiblanca, grown most widely in and around Priego de Córdoba for its sweet, fragrant oil, though the olives are so firmly attached to the trees that harvesting them is not easy. But it is also one of the most beautiful of cultivars. Thick clouds of leaves in lush clusters hang down almost to ground level. Those leaves are among the palest – Hojiblanca means 'white leaf' – and their undersides are covered in white indumentum that gives the whole tree a distinct brilliance in sunlight. There is no more lovely tree than a fully developed Hojiblanca shimmering in the breeze.

Catalonia is thought to have at least 80 different olive cultivars, which is unusual for a relatively small territory, especially after synonyms are eliminated. Much molecular work is done at IRTA, the regional research institute at Mas Bové in Tarragona, which recently identified 13 previously unknown cultivars in the *comarca* of Pallars Jussà in Lleida. When this systematic approach to our olive heritage is applied in every part of the Mediterranean Basin, the number of distinct olive cultivars will be much higher than the current world estimate of 2,000.

Clones and New Cultivars

There is however a benefit to be gained from olive cultivars that are widely grown, which is that growers occasionally notice small mutations that are by way of being improvements. These are then selected for propagation so that these improved forms, known as 'clones', establish themselves more generally in cultivation. This has happened with Frantoio and Carolea in Italy (where, it is said, ten clones of Leccino are in circulation), Picholine Marocaine in Morocco and Picual and Manzanilla de Sevilla in Spain. The olive known as Baladi in the Near East is an unusually numerous polyclonal cultivar. And the phenomenon has been seen in populations of Cobrançosa in Portugal and Gemlik in Turkey.

Recent olive-breeding has brought us new commercial cultivars that are measurably more useful. Kadesh, Barnea, Maalot and Askal were developed in Israel, Chiquitita in Spain and Arno, Tevere and Basento in Italy. The race has now begun to breed further cultivars that are resistant to *Xylella fastidiosa* and, more generally, new cultivars that can cope with global warming.

Density

Olive-growing has been revolutionised over the last forty years by the introduction of more intensive systems of cultivation. They have brought higher yields to answer the fast-growing demand for healthy, high-quality olive oil. It has also resolved the problem of a shortage of labour for pruning trees and harvesting olives in traditional groves. The owners of large, well-established trees need help with these crucial operations. The problem is that they – both the trees and their owners – tend to be elderly and cannot rely on family help with these tasks because the next generation has abandoned the countryside and moved to the cities in search of a less physical way of life. The cost of employing contractors to do the harvesting typically amounts to 40-50% of the total cost of producing olives.

Traditional olive growing requires patience. The trees may not enter full production for up to 20 years and have a tendency towards biennial cropping. Nevertheless, many olive groves, more than a century old, are still capable of producing good olives whose worth is enhanced by being of local varieties, recognised and valued for their place in the PDO legislation.

The olive trees in traditional plantations have a spacious layout, typically of 80 to 100 trees per hectare but fewer in difficult climates or on marginal land. The trees are rain-fed, so the wide spacing enables them to grow to a size where their roots can take advantage of the available moisture. However, in areas where the climate is not too dry and the soil retains water, these planting distances are now considered too high. Experts began in the 1970s to advise investors to adopt denser planting, from 200 to 500 trees per hectare and to harvest them with trunk shakers. This would lead to higher yields and lower costs. The trees would need modern pruning to encourage flower-bud formation and reduce the natural tendency towards alternate-year cropping. If these conditions were met, the right cultivars would come into production five to seven years after planting, and continue for several decades. At a certain point, olive trees start to yield smaller crops – this is a natural consequence of growing old – but we do not yet know how frequently it will prove necessary to replant intensive olive groves. Peach trees are usually replanted every ten years, but some intensive olive plantations are already 40 years old and still cropping well. They are unlikely to become large

Priego, Córdoba (Spain)

trees with the fat, gnarled trunks of traditional olive groves but their regular spacing and neatly-pruned outlines contribute much to the beauty of Mediterranean landscapes.

For intensive cultivation to be a success, it is important that the soil should be fertile, which rules out planting in traditional marginal sites like unterraced hillsides. Some fertilising is needed to encourage the growth of the trees – this may be organic or artificial – and irrigation will probably be needed, to supplement the natural rainfall. The yield, however, may rise to some 4,000 kg of olives per hectare, which is four times higher than can be expected from many traditional rain-dependent plantations.

Given the success of these intensive young olive groves, it was logical to suppose that even denser plantations would be yet more profitable. Researchers and plant-breeders looked for suitable cultivars. The Catalan agricultural research institute IRTA at Mas Bové in Tarragona built up a collection of improved olive clones and tested them for super-intensive cultivation, sometimes known as super high-density cultivation. These clones would be short-growing, vigorously branching and able to give a good yield at an early age. They could then be planted closely, supplied with irrigation and pruned and harvested by mechanical means.

In 1994, IRTA released three selected clones of well-known olive cultivars for this new super-intensive method of olive farming. Arbequina I-21, Arbosana I-43 and Koroneiki I-38 quickly became the most frequently planted of all olive trees, especially the Arbequina clone because the cultivar itself had for long been the most widely planted in Catalonia and was well known for the organoleptic qualities of its oil.

Super-intensive groves are usually laid out at a density of between 1,000 and 2,000 trees per hectare. The trees are planted 1.2-1.5 m apart, almost always by specialist contractors who also supply the plants. Irrigation is essential in periods of hot, dry weather, and drip systems are run along the lines which can also be adopted for fertigation. Almost all these super-intensive plantations are on flat or near-flat, fertile soils and all come into production quickly – three tonnes of olives per hectare can usually be harvested in the third year. These returns increase, so that by their sixth year a yield of between 8-12 tonnes per hectare can be expected. And there are reports of plantations in warm areas which, with appropriate management, produce up to 16 tonnes of olives per hectare annually. The trees need regular pruning and fertigation to succeed, and extra water in times of shortage, but their oil is of the highest quality, always extra virgin.

Key to the success of super-intensive olive-farming is mechanisation. Annual topping at a height of 2-2.5 m is carried out in summer, together with pruning the sides to keep the lower branches (up to 60 cm from the

base) in production. These tasks, and harvesting too, are often undertaken by the contractors who first planted the trees. Mechanical harvesters straddle the rows and use soft flexible rods to detach the olives. The aim is to harvest as much as possible (typically, up to 98% of the fruit) while avoiding damage both to the fruit and to the trees themselves.

The Arbequina I-21 clone is the most widely planted olive for super-intensive farming, not just in Spain but also in the rest of the world. The variety takes its name from its place of origin, the village of Arbeca in Lleida. It is self-fertile and comes into production early, with a high and constant productivity. Its oil is notably fruity and especially valued for pouring over salads, fish, white meats and vegetables. Its oil is not long-lasting – the distinctive taste begins to fade after a few months – but it is greatly valued by big blenders for its ability to combine well with other oils.

Arbosana is another Catalan cultivar, genetically quite closely related to Arbequina and valued for its high degree of self-fertility and its consistent levels of productivity. The fruit is ready for picking conveniently later than Arbequina and the oil is of fine quality.

Koroneiki is a Greek variety that comes into production even earlier than Arbequina and is notably drought-resistant. It has a tendency towards biennial cropping that can be controlled in super-intensive plantations by the system of regular topping and pruning. It gives a good yield and the oil is very fruity and stable. That stability is one of its greatest merits – it keeps its flavour and its freshness for up to two years, which is much longer than Arbequina and Arbosana.

Super-intensive plantations spread quickly all around the world – they are now the norm for commercial plantations everywhere. This acceptance by the international olive oil community is reflected in the volume of new research undertaken to develop and improve the system through breeding programmes and rootstocks selection. Two new cultivars from Italy with all the required qualities are Diana and Tosca – Diana is also reputed to be resistant to *Xylella fastidiosa*, the bacterium that has brought such damage to olive groves in Puglia. And the Andalusian Institute for Research and Training in Córdoba has introduced Sikitita (also known as Chiquitita) to combine the qualities of Picual, the Andalusian king of olives noted for its productivity, with the taste and adaptability to intensive cultivation of Arbequina. It is said to be suitable for plantings of up to a density of 2,000 per hectare.

There is some uncertainty about the long-term effects of super-intensive plantations upon the environment. Clearly, they break with the traditional image of the olive as a fine tree that will grow in poor soil, survive drought and still produce good crops of olives both for oil and for the table. And the olive is the tree, perhaps

above all others, that typifies the Mediterranean landscape. A traditional olive grove is environmentally sustainable; super-intensive olive cultivation is not – it creates an artificial environment that makes an increased demand for water and greater use of phytosanitary products. Critics suggest that it may lead to soil compaction and erosion, perhaps even to desertification that is incapable of ecological restoration. There are human costs, too. The need for labour is greatly reduced, though this was one reason for developing the new plantations in the first place.

Super-intensive plantations do not have the same landscape value as older olive groves and rugged individual trees, but they still create a favourable impression. They are as pleasing to the eye as a hillside covered in neat, well-pruned vines or, in cooler climates, the rows of apple and pear trees that promise the good things to eat that we all enjoy. They speak to us of prosperity, order and good cultivation.

Oldest Trees

Every country around the Mediterranean Sea has, at some point, claimed to have the oldest olive tree in the world.

Olive stones from the Minoan civilisation conserved in the Heraklion Museum, Crete (Greece)

The Stara Maslina tree at Stari Bar in Montenegro – a popular tourist attraction – is estimated locally to be over 2,000 years old. The Oliveira de Mouchão near Abrantes has a hollow trunk, but is still standing. The Portuguese claim that it dates back to the Atlantic Bronze Age – roughly 1,000 years BC, which would make it more than 3,000 years old. A wild olive in Sassari, known as the Olivastro di Luras, is thought by Sardinians to be the oldest in Italy, starting life perhaps as much as 4,000 years ago. Greeks maintain that the olive tree at Vouves in Crete could be even older, as much as 5,000 years old. Nevertheless, it seems that the crown for estimating the oldest of all olive trees still standing and bearing fruit must go to one of the trees known as The Sisters in northern Lebanon. There is considerable doubt about their exact age, but the Lebanese put it as anywhere between 5,000 and 6,000 years old. This would make them the oldest non-clonal living trees in the world, older even than the most venerable bristlecone pines (*Pinus longaeva*) in the mountains of Nevada, USA.

Unfortunately, champion trees of any species are seldom as old as their supporters would like to believe. It was once universally accepted that the Bidni olive trees in Malta were 2,000 years old, which means that they were already growing when St Paul first set foot on the island. Unfortunately for Maltese

Procession of Egyptian soldiers and Nubian mercenaries carrying olive branches and axes, 1470 BC, Neues Museum, Berlin (Germany)

Olive trees and partridges, 1500 BC, Heraklion Museum, Crete (Greece)

Eagle with an olive branch in its beak, 2nd century BC, Archaeological Museum, Palmira (Syria)

national pride, the trees have now been tested with the science of dendrochronology and found to have been planted in the 17th century. All over the Mediterranean, the age of individual trees is over-estimated by faithful believers, until such time as they are confounded by scientific studies. Then the scientists become the villains who speak untruths about the trees that are very much older than the ignorant boffins claim.

In temperate climates, trees and shrubs form a new growth ring every year. The traditional way of estimating the age of a tree was to cut it down and count those annual rings. Nowadays such assessments are made not by felling the tree but by drilling a very thin cylinder of wood right to its core. This is the basis of dendrochronology, the science not just of assessing the age of trees but also of studying ever-changing climatic conditions over the years.

The problem is that this does not work so well for Mediterranean climates as in temperate and continental regions where these annual rings are clear and easy to count. Olive trees do not always show distinct rings and their pattern of growth is somewhat contorted. And, as an extra complication, olive wood tends to develop markings known as intra-annual density fluctuations (IADFs) during drought or periods of temperature fluctuation. This means that it is often difficult to distinguish true annual growth-rings from IADFs.

Radiocarbon or Carbon-14 dating will give a much more accurate estimate of the age of an olive tree but old trees present the same problems that affect conventional dendrochronology. First, the centre (the oldest part of the trunk) tends to rot away, leaving a hollow centre that gets larger as the outer parts continue to grow away. Second, olive trees regenerate from their roots – specifically from the lignotuber at the base of the trunk – which means that they can regenerate after fire or frost. It follows that the roots may be much older than the tree we see today.

There is an area in eastern Spain, not far from the sea, known as the Territory of Sénia, which has a notable concentration of nearly 5,000 olive trees, all with a circumference of 3.5 m or more at 1.3 m from the ground. All have been estimated to be at least 1,000 years old, and some to exceed 2,000 years, but still producing olives. The trees are of the Farga variety, which gives a delicious, smooth oil but is seldom planted now because it is not very productive. Indeed, until a few years ago, many of these trees were dug up and sold as handsome features for gardens and parks. Now the entire concentration of massive trees is a tourist attraction in its own right and several landowners offer 'millennial' oils made exclusively from the olives of these ancient trees.

However, two studies by the Polytechnic University of Madrid (UPM) have established since 2012 that these trees are younger than supposed. The team measured the diameter and girth of the trees whose wood still had complete rings and extrapolated their findings to calculate the age of older trees with hollow centres. This enabled them to establish the relationship of diameter to age. A fine specimen at La Jana in Castellón was 1,184 years old, planted in 833 during the emirate of Abderramán II (822 to 852 AD). Oldest of all in 2015 was 'La Farga de Arion' at Ulldecona, which had an estimated age of 1,701 years and would therefore have been planted in 314, when Spain was ruled by Constantine the Great, the first Christian Emperor of Rome. It has now been declared the oldest olive tree in Spain.

There are competitors. These include an olive tree near Gorga in Alicante, that is said to be more than 2,000 years old. Although almost certainly younger, it has lost much of its heartwood while at the same time expanding outwards. Its perimeter now measures more than 13 metres but its probable age has not yet been put to the test. It is said that in the 19th century, a local family decided to take advantage of the hollowness of its trunk to make a house where they lived for many years. Gaps in the trunk provided two doors and several natural windows. No-one lives there now, but there is a bench inside the tree where visitors may take shelter from sun and rain and contemplate not just its unusual history but also its ability to crop well still, averaging some 200 kilos of olives in recent years.

Athlete crowned with an olive wreath, 50-30 BC, Archaeological Museum, Izmir (Turkey)

The olive trees in the Garden of Gethsemane in Jerusalem have always had great significance for Christians and some of them are claimed to date back to the time of Jesus. An Italian research team inspected them in 2012, using carbon dating on the oldest parts of their trunks. Because their trunks are now so hollow, it was possible only to come up with the ages of three of the trees which were duly estimated to have been planted in 1092, 1166, and 1198. DNA tests showed that they were all of the same variety – one that is no longer known elsewhere. However, it is claimed that the rootstocks on which they and several other trees at Gethsemane were grafted are much older. Apparently, a team of California scientists carbon-dated them to be about 2,300 years old. This is entirely credible: it will be interesting to see the Americans' report, when it is published.

Former family dwelling in the belly of a 2,000-year-old olive tree, Gorga, Valencia (Spain)

Greeks are certain that the Vouves Olive Tree in Crete is the oldest in the world. Wreathes were made from its branches to crown the winner of the Marathon race at the 2004 Olympic Games in Athens. In classical times, the crown of olive leaves was made from a sacred wild olive on Mount Olympus.

Many of the oldest olive trees are oleasters that were good enough to avoid being cut down. Lo Parot is near Horta de Sant Joan, the village in Tarragona's Terra Alta Region where the teenaged Pablo Picasso lived for a year. It is not unlike the local Empeltre variety but unknown anywhere else – perhaps the last survivor of a forgotten cultivar. The tree belongs to a farming family, who bought it at the beginning of the 20th century, on the condition that it would never be cut down, and it remains in excellent condition.

One can but stare in wonder at the beauty and complexity of so many old olive trees. however, it is fair to conclude that most 'veteran' or 'monumental' trees are between 300 and 500 years old, and *not* the 3,000 to 5,000 years that their protagonists proclaim. Theophrastus (371-287 BC) got it right when he wrote:

"Perhaps we can say that the longest-lived tree is the one that in every way is capable of persisting, as the olive tree does because of its trunk, because of its power to develop lateral growth and because of the fact that its roots are so difficult to destroy."

N'Espanya olive tree,
800 years old, Ibiza (Spain)

The Bible

The olive has a special importance among Jews and Christians. According to the Book of Deuteronomy, the "prosperous land" that God promised to the Israelites was "a land of wheat and barley, of vines, of figs, of pomegranates, a land of olive oil and honey."

For Jews and Christians alike, one of the most significant images of olive trees appear in Chapters 6 to 8 of Genesis. It tells how God commanded Noah, "a man of integrity", to build a wooden boat ('the Ark') in which he and his family would escape the Great Flood that was to come. Noah was also instructed to fill the boat with a male and a female of:

> "Every species of wild animal, every species of cattle, every species of creeping things that creep along the ground, every species of bird, everything that flies, everything with wings."

Then the rain fell, the land was flooded, and Noah's Ark floated for nearly a year until it was grounded in a place known as Mount Ararat. When Noah released a dove, to see whether the waters were receding from the surface of the earth, the bird could find nowhere to perch and returned to the Ark. One week later, Noah sent out the dove again and once again it came back, but this time with a freshly picked olive leaf in its beak. So, Noah realised that the waters were receding and, another week later, began to disembark. The olive leaf then became a symbol of peace. Today, in many languages to 'offer an olive branch' is a metaphor for seeking peace.

The importance of an oil with so many virtues elevated it as a gift from God. Oil was a source of lighting that transformed the lives of our ancestors. The hours of darkness were no longer a source of terror but could be put to good use. In return, Moses was told to "order the sons of Israel to bring pure olive oil for the light" in their place of worship "and to keep a flame burning there perpetually." This was to be "an irrevocable ordinance for their descendants, to be kept by the sons of Israel."

In the Book of Exodus, God instructed Moses to make holy chrism with which to anoint all that was sacred. The recipe was based on olive oil made fragrant with fresh myrrh, cinnamon, cassia and a scented reed, blended together as a perfumer would. This holy oil was used to anoint the tent where the Israelites came together to worship, and all its sacred furnishings, including the altar of burnt offerings. The oil should be used to consecrate priests "for all your generations to come". Olive oil was also prescribed as an essential

**The Jewish cemetery
on the Mount of Olives,
Jerusalem (Israel)**

part of the purifying sacrifice of atonement. Later on, these practices were substantially adopted by Christians. Among Catholics today the altars and walls of a new church are consecrated by a bishop, as are such sacramental implements as patens and chalices.

The book of Elijah tells the story of the prophet meeting a widow at a place called Zarephath during a drought that had made foodstuffs very scarce. Elijah asked her for a piece of bread, but she said she had none to offer him – all she had was a handful of flour in a jar and a little olive oil in a jug. She intended to bake them together as a last meal for herself and her son "and then we shall die". Elijah asked her to make a small loaf for him first and then make something for herself and her son. And he promised that "the jar of flour will not be used up and the jug of oil will not run dry until the day the Lord sends rain on the land." The widow did as she was asked whereupon the prophecy was fulfilled so that the flour and oil were constantly replenished and all three of them – the widow, her son and Elijah– had enough to eat until the drought ended and new supplies of food were available again.

King David, who wrote the psalms, compared himself to a green olive tree and added "I will always trust in God's unfailing love." Like modern pop-singers, David usually sang about himself but, in Psalm 128, he offers a beautiful image of the blessings that come from obedience to God: "Your wife shall be like a fruitful vine within your house, your children like olive plants around your table." As an old man, King David fled Jerusalem and climbed the Mount of Olives, barefoot and weeping, when he realised that his son Absalom was conspiring against him.

Jews held that when Adam and Eve were expelled from the garden of Eden, they were allowed to take seeds of the olive, the cypress and the cedar from the Garden of Eden. These three trees were, each in its own way, invaluable to the well-being of Adam's descendants and came to be regarded with a degree of respect that rendered them special. The Jewish prophet Jeremiah recalled that God had called the people of Israel "a thriving olive tree, with fruit beautiful in form" and warned that if they forgot what they owed to him "with the roar of a mighty storm he will set it on fire and its branches will be broken." The laws laid down in Deuteronomy insisted that the fruit of an olive tree should only be harvested once by the owners; he should then leave what then remained on the tree for strangers, orphans and widows to glean. This is still a common practice in traditional societies.

Scholars have for long debated the age of the books of the Old Testament. The date when they emerged in their present form obscures much older sources that were pulled together for the final compilation. Some details of the Book of Genesis, for example, may date back to 1,000 BC, but many scholars maintain that it was more likely to have been written in 600 BC or 500 BC, and others propose it to date from as late as the third century BC. These uncertainties do not undermine the enormous religious and cultural importance of all parts of the Old Testament, but they do mean that the Bible stories cannot be used to date the evolution of olive-growing and the emergence of olive and olive oil in the culture of peoples of the Middle East.

Olive tree in the House of the Virgin Mary, Ephesus (Turkey)

Jesus was "of the house of David" and returned to the Mount of Olives the day before his crucifixion, where he prayed and was comforted by an angel. Even today, worshippers take a sprig of olive to their Palm Sunday processions, not a frond from a palm-tree. And, fundamental to Christianity, is Jesus's identity as 'the Christ', meaning the Anointed One.

Christians believe that Jesus was the fulfilment of God's promises to the Jews. In his letter to the Romans, St Paul writes about grafting the Gentiles – Christians who were not of Jewish origin – onto Jewish root-stocks, a practice that he described as "contrary to nature". Nevertheless, Christians would benefit from the graft because now they would share the nourishing sap of the Jewish olive root.

Olive oil maintains its importance as a sacred symbol in the writings of the New Testament, especially as a treatment for healing wounds. St Mark recounts that, when Jesus summoned his apostles and sent them out to preach repentance, they anointed the sick with olive oil and cured them. When the Good Samaritan took pity on the stranger who had been mugged on the road from Jerusalem to Jericho, he poured wine and olive oil into the man's wounds to cleanse them. Years later, St James urged Christians, if a person fell sick, to pray over them and anoint them with oil.

The custom of keeping a light burning in perpetuity was adopted by Catholic and Orthodox Christians, who place a small red lamp in front of the tabernacle of the consecrated Host. In England, during the years of persecution by Protestants, the few Catholic families who retained their faith kept a lamp alight in their secret places of worship to signify the presence of Christ in the Blessed Sacrament.

The practice of anointing with olive oil was adopted by Christians and extended to specific sacramental uses. At their baptism, their forehead is anointed with the oil of catechumens, which is olive oil that has been consecrated by a bishop at an annual ceremony. This 'oil of gladness' is a symbol of the Holy Spirit. When they are confirmed as Christians, they are anointed on the forehead with oil If they are ordained as priests, they are anointed on their hands. And chrism has long been used as part of the coronation ceremonies of Christian kings and queens. All kings of France from Louis VII in 1137 to Charles X in 1825 were consecrated with chrism, as was Napoleon I, as emperor, by Pope Pius VII in 1804. King Charles III of the United Kingdom was consecrated with holy oil as part of his coronation ritual in 2023.

The Olive Tree in Roman Times

"The olive-tree, the queen of all trees, requires the least expenditure of all. For, although it does not bear fruit year after year but generally in alternate years, it is held in very high esteem because it is maintained by very light cultivation and, when it is not covered with fruit, it calls for scarcely any expenditure; also, if anything is expended upon it, it responds by multiplying its crop of fruit. If it is neglected for several years, it does not deteriorate like the vine but, even during this period, it still yields something to the owner of the property and, when cultivation is again applied, it recovers within a year."

Lucius Junius Moderatus Columella (4 – c.70 AD).

Olive oil was essential to the life and culture of Ancient Rome. Pliny the Elder sums it up in his *Naturalis Historia*:

"There are two liquids that are especially agreeable to the human body, wine inside and oil outside, both of them most excellent… but oil an absolute necessity."

Many Roman authors wrote about olive trees including Varro (*De Re Rustica*) and Virgil (*Georgica*). Their knowledge, care and appreciation of olive trees and olive oil are exemplary. Much of what they wrote corresponds with traditional practices today – their observations and advice are immediately understandable. Only when they say things that surprise us do we need to reflect. Two of the most interesting are Lucius Junius Moderatus Columella and Cato the Elder, just two of the many ancients who wrote about olive-growing.

In the first century AD, Columella wrote that he knew of ten different varieties of olive trees though he supposed that there were others that he had not encountered. Some were best for eating and others were best for their oil. In a very hot climate, olive trees "rejoice in the north side of a hill; in cool districts in the south side." The 'Posia' variety stands the heat best, and the 'Sergian' tolerates the cold. We have no way of knowing whether any Roman varieties still exist today, grown under modern names.

Columella gave detailed advice on where olive trees would grow well. Most olives preferred a countryside of gentle slopes, such as the Sabine hills north of Rome, still a prime area for olive trees. Columella also commends "every part of the province of Baetica", which roughly corresponds today to the Spanish region of Andalusia, famous for the scale of its olive plantations. Most appropriate for olive-growing was a good

Roman mosaic, Bardo National Museum, Tunis, (Tunisia)

topsoil overlying gravel, or a sandy loam. Olives would not grow well, however, in pure sand, gravel or chalk. They needed a richer mixture, such as land that had been cleared of wild arbutus or holm-oak woodland. Columella also noted that olives thrived on rich land that had previously grown wheat, even though this might better be used for more intensive cultivation.

The production of young olive trees – what we would call nursery stock – was clearly an activity of which Columella had extensive experience. He recommended propagating them from hardwood cuttings inserted into soil that had been dug over and allowed to settle. He advised that the cuttings should be inserted into the soil with their growth points above the soil level and their older wood beneath – and he noted that the best 'take' came from the youngest wood. It would be five years before the new trees ("thick as a man's arm") were strong enough to be transplanted into their permanent positions. The planting holes should be prepared well in advance, so that the soil into which the trees were inserted was friable and would retain moisture while the plant established itself. If the soil were naturally moist, transplanting should take place in spring but in dry sites it was better done in the autumn, so that the plant benefited from winter rains.

Columella recommended that olive trees should be planted in rows and aligned towards the west, so that they might be cooled by the summer-breeze blowing through them. Other Roman writers suggested that this would help the olives to ripen equally. Where the farmer intended to grow crops between the rows, Columella specified a spacing between trees of 60 feet in one direction and 40 in the other, though 25 feet would be enough if the soil were poor and not suitable for catch crops. A Roman foot equals 296 mm today. When it came to transplanting, the trees should be lifted with their rootballs intact so that their roots were not damaged. Establishing the young trees – transplanting them successfully – was clearly a delicate operation because Columella gives detailed instructions on how this should be done. Then the young plants should be watered in dry weather until they were properly established. They should also be fenced to protect them when the land in between the rows was ploughed. And they should be trained to a single trunk "as high as an ox is tall", so that they would be safe from the predations of goats. The ancient Roman writers were unanimous in saying that goats were the worst pests of olive trees and, indeed, of all agricultural activity, because their nibbling ruined everything growing, not least the vines and olives.

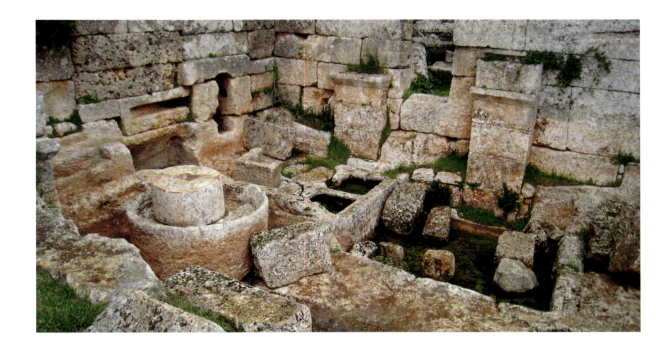

**Olive press,
5th-6th century,
Serjilla (Syria)**

Columella noted that olives tend to crop well biennially. His solution was to divide the olive grove into two parts and leave one of them fallow so that the trees could make good vegetative growth, and to cultivate the other half, so that the olive trees also fruit. He does not, however, tell us exactly how this system was made to work. Nowadays, we find that the pattern of alternate-year cropping is established when olive trees are young, perhaps as a result of a setback that leads to a year of reduced yields that is then followed by a year of plenty. Columella also gives good advice on pruning and manuring – the principles he articulates hold good even today – and he quotes an old proverb: "the man who ploughs the olive grove, asks it for fruit; he who manures it, implores it to fruit; he who lops it, forces it to produce fruit." He does however advise farmers to limit this lopping, which we would now call renewal pruning, to eight-year intervals.

Columella is largely concerned with the propagation, establishment and management of an olive grove. Two centuries earlier, in about 160 BC, Marcus Porcius Cato (234–149 BC) had already written about procedures for pressing the olives for their oil. Cato's work *De Agricultura* was one of the first of all Roman writings to be written in Latin that have come down to modern times. He began by asserting his opinion that picking should be done by hand, because beating the branches to dislodge the olives could bruise them, as well as damaging the tree so that it cropped less next year. Nowadays, growers accept that the equipment they use to pick their olives will also bring down leaves and twigs, but these are winnowed out before the fruit goes down to the presses.

Cato advised that:

> "When the olives are ripe, they should be gathered as soon as possible, and allowed to remain on the ground or the floor as short a time as possible, as they spoil on the ground or the floor."

This observation is still true: fallen olives start to corrupt and the mould gives an unpleasant taste to the oil. Cato explains that:

> "The gatherers want to have as many windfalls as possible, that there may be more of them to gather; and the pressers want them to lie on the floor a long time, so that they will soften and be easier to mill. Do not believe that the oil will be of greater quantity if they lie on the floor. The quicker you work them the better the results will be, and you will get more and better oil from a given quantity. Olives which have been long on the ground will yield less oil – and of a poorer quality."

When olives were preserved for eating, Cato advised soaking them in brine. Ripe olives could also be preserved by packing them in salt for five days and then drying them in the sun

Cato was a successful soldier who served as consul in 195 and 183 BC. He was evidently a tidy man who ran an efficient and orderly estate:

> "When the vintage and the olive harvest are over" he wrote, "raise up the press beams, and hang up the mill ropes, cables, and cords on the meat-rack or the beam. Put away the stones, pins, levers, rollers, baskets, hampers, grass baskets, ladders, props, and everything which will be needed again, each in its proper place."

He also gave detailed advice on how many workers were needed to run an olive estate. For example, a farm of about 65 hectares required a manager, a housekeeper, five workers, three ploughmen to drive the oxen, one swineherd, one donkey driver and one shepherd. It goes without saying that all would be slaves who belonged to the landowner. And Cato argued that a landowner should keep his estate in an ordered way, not just because this would increase its productivity but also because it would increase its value if he should wish to sell it. "If two things are equally useful", he declared, "who would not choose the better looking?"

Conservation & lifestyle

Cultivation

The olive tree is a Mediterranean species and naturally adapted to the Mediterranean climate. It will grow at altitudes from sea-level to 1,000 metres, except for exceptional cases like the olive trees in Barreal, Argentina, which grow at over 1,600 metres, and requires full sun in summer. It fares best in temperatures between 15°C and 25°C but most cultivars will tolerate lows of -8°C and highs of 35°C. The optimum annual rainfall is around 700 mm, most of it falling in winter. It tolerates drought in summer, but prolonged lack of water affects the growth of the tree and the formation of leaves and fruits.

Long winter freezes will kill an olive tree to the ground. Many trees suffered this fate in Syria in 1949, Provence in 1956 and Tuscany in 1985, with severe financial and social consequences for farmers and their neighbours. However, trees usually regenerate from the roots, which is why olive trees are sometimes said to be immortal. A millennial oleaster from the Alto Maestrazgo in Castellón was cut to the ground by exceptionally hard frost in 1956 and showed no signs of life for 50 years. Then, at last, it sent out new shoots from deep inside its gaunt, leafless skeleton. By 2012 it had grown back enough to be voted 'Olive tree of the Year' by the Asociación Española de Municipios del Olivo.

Towering olive trees that let their olives fall to the ground to be collected little by little, Corfu (Greece)

Toledo (Spain)

Other hazards of freak weather include continuous rainfall or hot temperatures during pollination and gales just before and during the harvest, which knock the fruit off the trees. On the other hand, late summer thunderstorms are welcomed because the rain increases the size of the olives and their yield of oil. This explains why many modern plantations are irrigated in late summer and early autumn.

Olive trees need a cool winter to set the flower buds from which olives will follow. For most varieties that temperature is around 10ºC but different varieties require different degrees of chilling. Without chilling, some cultivars like Empeltre in Aragon and Frantoio and Leccino in Italy will not flower, and the same is true of some important table olives, including Spanish Gordal Sevillano and Italian Ascolano. But some cultivars need less chilling; these include Koroneiki, Coratina and Arbequina as well as many North African varieties, which have been selected over the centuries for their ability to flower and fruit despite the absence of winter cold.

Olive trees are said to prefer alkaline soil. This is not true. What olives need is sharp drainage, and they will flourish on other soil types if this is available. The important requirement is an open structure with good

Guadalajara (Spain)

water retention for their roots to explore. Agronomists today worry about soil degradation and desertification as a consequence of poor cultivation, aggravated by drought; the answer, they say, is to grow ground-cover plants between the rows of olive trees to retain moisture and fertilise the soil naturally.

There are three ways to propagate new olive trees: by seed, grafting and taking cuttings. Seedlings do not come true to type, so their principal use is as rootstocks in areas where grafting is the main method of propagation. Some varieties are difficult to grow on their own roots and are usually grafted. These include Ascolana, Empeltre, Valanolia, Salonenque and Chemlali. Most cultivars can however be grown from cuttings, which is the quickest and cheapest method of propagation. And if a tree is growing on its own roots but is cut to the ground, for example by a period of exceptionally cold weather, the 'right' variety will sprout up again. Cultivars that root easily from cuttings include Arbequina, Frantoio, Gemlik, Ficudo, Coratina and Moraiolo. Modern nurseries use half-ripe cuttings and grow them first in polytunnels with bottom heat to encourage quick rooting, plus mist to protect them from drying out. This technique, which enables a large number of plants to be raised in a short time, is often supported by governments that seek to increase their olive production quickly.

The oldest olive trees in South America, approximately 452 years old, Ilo Valley (Peru)

When choosing which olives to plant, it is important remember that many cultivars are self-sterile and need a pollinator to set fruit. Popular, hardy and healthy Leccino, for example, is self-sterile but a good pollinator for many other cultivars. So are the really important Bosana, Coratina, Moraiolo and Canino olives from Italy, Groussane and Lucques in France – and many other cultivars all through the Mediterranean.

The density of planting depends on many factors, including the vigour of the variety – the Sicilian Nocellara del Belice, for example, is well-known for its straggly growth – and whether or not the trees will be irrigated. Access for harvesting machinery is also a consideration. Traditional cultivation requires about 250 trees per hectare to be an economic reality – and no more than 300 per hectare – with the rows spaced 6 to 8 m apart and 5 m between the trees. If the trees are allowed to grow together and shade each other, yields will be reduced. In areas like southern Algeria, where rainfall is low and irregular, the average density may be less than 40 trees per hectare. With mechanical harvesting of irrigated trees it is generally possible to plant with a closer spacing – rows of 5 to 7 m with the trees planted on a staggered formation at 3 to 5 m apart. This will permit a density of 400 to 500 trees per hectare. But dense planting comes with increased costs of maintenance.

**Tacna Region (Peru),
with a bigger yield
of olives than France**

Mirandela (Portugal)

Olive trees in traditional plantings are usually trained to a central trunk, then pruned to create four or five large branches. Once the tree starts cropping, maintenance pruning is aimed at sustaining production by letting the leaves receive sunlight. Old, abandoned or neglected trees benefit from drastic regenerative pruning, which will create a thick new rush of twigs that, when suitably thinned out and trimmed, will develop into fruiting branches. The olive prunings are useful as animal feed and the thicker sections of wood make good fuel. Trees generally reach their maximum yield when they are about 40 years old, and then start to decline, though they may not be worth replacing for perhaps another 30 years.

Pests and diseases are a nuisance to olive farmers but most are easy to control. The most serious, especially at lower altitudes, is the olive fly, *Dacus oleae*, which lays its eggs in the developing fruits. Sometimes the olives then fall to the ground but, if they stay on the tree and are picked, the worms in the

**Fuente de Piedra,
Málaga (Spain)**

**Coosur Olive Mill, Jaén (Spain).
Avant-garde designs with
an eye to olive oil tourism**

olives impart a disgusting taste to the oil and render them unusable as table olives. Naturally, the olive flies prefer the larger olives. Nowadays, the insects are controlled by pheromones that lure over-sexed males to their death. Many other insects and micro-organisms prey on olives but the fly is the one about which worried growers speak most.

Crops are affected by the olive tree's natural habit of biennial bearing. A year of plenty is followed by a year of paucity. Biennial production seems not to affect just individual olive trees but a whole grove, an area and an entire country. Turkey produced 421,000 tonnes of olive oil in 2022, but less than 200,000 tonnes in 2023. The problem may be partially mitigated by fruit thinning, fertilisation, irrigation and pruning. The individual olives in a good year are often rather small, but their weight may nevertheless cause branches to break

Most olive-picking is done by machines. One method involves shaking the whole tree so that the olives drop into a sort of large umbrella secured around the trunk. Manual pickers use long-handled rakes, which may be battery-powered, to shake the twigs and pull down the olives. Smallholders may detach the olives by

Ultra-modern olive oil processing plant, Longnan (China)

running their hands along towards the tips of the branches. It is best to start picking early on; the olives may be more difficult to dislodge but the quality of the oil will be better.

It is important for pickers to get the olives to the mill as soon as possible and many landowners and cooperatives have strict rules about the time this takes. The most obsessive boast is of getting them milled within one hour, but the general rule is that every day's pickings should be milled within 24 hours. This is, however, a counsel of perfection for traditional farmers who may have harvested their olives by knocking them off the tree with a long stick and need to build up a volume of olives large enough for the mill to be willing to press them.

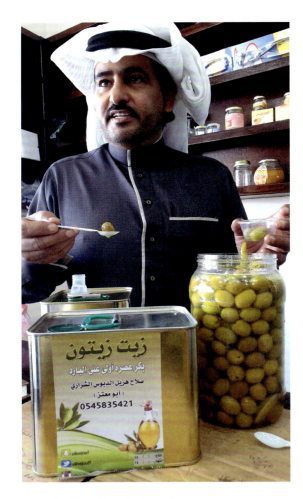

Store in Yauf (Saudi Arabia)

Shop selling products from the olive tree, Longnan (China)

The Italians sell it like gold

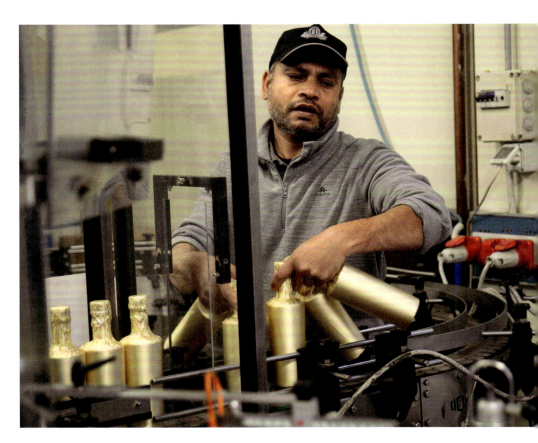

Olive oil bottles wrapped in gold paper,
Imperia, Liguria (Italy)

The oil content of olives is affected by many factors. Cultivars like Picual are popular because their yield may be as much as 28%, whereas Aggezi Shami, the much-prized Egyptian table olive, gives no more than 8% of its weight in oil. Temperature also has an effect on yields: the Arbequina cultivar yields 20% of oil in Catalonia but only 12% in the hot climate of north-west Argentina.

In traditional farms and smallholdings, olive trees are incorporated into mixed plantings. Their growth cycles fit in with other economic crops. Grapes, for example, are picked several weeks before the olive harvest begins. This crop diversity is essential for a small's farm's viability, and a surplus can always be traded.

Table olives

The principal purpose of cultivating olive trees is to press the olives for their oil. However, olives are also eaten as food, usually after they have undergone treatment to preserve them from decay. Table olives are part of the diet and cuisine of all Mediterranean countries.

The Roman writer Columella confirmed what has been known for centuries i.e. that "generally speaking, all the bigger olives are more suitable for eating, the smaller for oil." This is still the practice today, though the total yield is not actually affected by the size of the olives. Each tree has a limit to its potential and so it is the total weight of the crop that determines the number of individual fruits produced. Some varieties grown principally as eating olives are also known to make good oil, including Kalamata and Gordal Sevillana. And some smaller olives are also grown because of their excellent flavour. Tanche and Picholine Marocaine are examples of dual-purpose olives. The black Tanche olives are considered France's best and carry a substantial market premium. The legislation that governs their production insists that they should have a minimum diameter of 14 mm. Second grade olives are up to 16 mm in diameter, first grade up to 18 mm and any olives still larger can be sold as 'extra' sized olives. The little ones left over after grading are pressed for their oil.

Table olives need careful picking, which is often done by hand, especially in traditional plantations, so that the pickers can check that each olive is in good condition, free from mould and fly-larvae. Some modern machines, working in suitable plantations, can harvest large olives safely without bruising them. Then they

Olives from the giant olive tree, Baja California (Mexico) see p. 215 for the Baja California olive tree

Olives in brine, El Cairo (Egypt)

are preserved, in accordance with local tastes and traditions, to remove their bitterness, a process that usually involves fermentation.

Table olives are classified by their colour at harvest time – green, black or half-in-half – which determines how they will be processed and preserved. Green olives are unripe fruits. They are preserved in one of several different ways. The most common is known as the Spanish or Sevillian method. Olives are soaked in diluted sodium hydroxide to remove the bitterness, thoroughly washed and then fermented in brine by the natural yeasts and malolactic bacteria that naturally occur on their skins. When the fermentation is complete, they are washed again and preserved in salted water. This method is used for Manzanillo and Gordal olives in Spain, and Picholine Marocaine in Morocco. There are several variations on this procedure. The Sicilian or Greek method is applied to olives, whatever their colour and ripeness, which are fermented without prior treatment with sodium hydroxide. The brine is changed several times and, at the end, the olives are stabilised in a weak acid solution based on lemon juice or vinegar. The Picholine

method of fermentation is also similar to the Spanish process but the olives may be green, semi-ripe or black, and they are soaked in lye for longer periods.

Other cures for table olives include: Lebanese or Phoenician fermentation, whereby olives are crushed to hasten the fermentation process; pure water fermentation, for which the olives are steeped in water or weak brine that is changed daily for up to a fortnight; and salt-cured, where ripe olives are washed, then packed in salt to draw out the moisture – a popular process in North Africa and the Near East. There are yet further cures for table olives, of which the best are those that require lactic fermentation because the olives can then be stored without the need for refrigeration. Spain and Egypt are the largest producers, followed by Algeria, Turkey and Greece. As with olive oil, the volumes vary from year to year according to the size of the harvest.

Conservation

Olive landscapes are changing fast. Olive-growers are converting to intensive and super-intensive plantings. Old groves are abandoned because they are no longer viable. Terraces are collapsing. Traditional olive varieties are replaced by all-conquering Arbequina and Picual. The landscapes we so value today will vanish soon enough. Or will they? The heritage of thousands of years of olive-growing is worth preservation. Not everything, perhaps, but there is still so much to learn from the past for future generations to enjoy. And conservation is a major industry.

Olive-farming has improved dramatically over the last fifty years. Standards of cultivation, harvesting and storage are much higher than in the past, as are the market expectations of consumers. Respect for conservation already exists alongside better management and higher yields. Olive production must combine better socio-economic prospects, respect for natural resources and wholesome ecosystems. Olive-growing is not just an economic activity; it also carries cultural and social responsibilities.

Marginal land is the first to be abandoned. The terrain is difficult to adapt to modern machinery and ways of working. And the returns do not justify the high cost of seasonal labour. Steep terraces at high altitudes are no longer an economic proposition. At 1,000 m altitude above Morilla in de-populated Teruel, the olive trees are dying from neglect. In wealthy Tuscany, 30% of olive groves have been abandoned. Conversely, in

poorer areas like the mountains of North Africa, the easy availability of cheap labour – usually women and children – militates against investment in the machinery and methods that would bring a higher quality product and, with it, higher returns.

Many UNESCO World Heritage sites are set among ancient olive trees. The Greek temples at Agrigento in Sicily and the Pont du Gard in southern France – plus Castel de Monte and the Trulli of Alberbello in Puglia – are all enhanced by the olive trees that surround them. Olive trees are, in any event, a substantial part of some UNESCO landscapes, including the Val d'Orcia in Tuscany and the Serra de Tramuntana in Majorca. The regional governments of Italy have already selected their best olive landscapes for conservation. Examples of special value are the terraced olive groves of Vallecorsa in Lazio, the millennial olive trees in the plain of Brindisi, and the Parco Regionale dell'Olivo di Venafro, which Ancient Romans considered the best village for olive oil.

The European Union (EU) encourages the owners of old olive groves to allow grass and wild flowers to flourish between the rows. The grass is treated as mulch, along with the winter prunings, while natural legumes like clovers and vetches fix nitrogen from the air and add fertility.

Ancient olive trees are admired for their contribution to the landscape, but the farmer knows that they occupy too much space and give poor returns. He would like to replace them with young trees, and will not be pleased when his older trees have a conservation order placed upon them. He will tell you that large old olive trees are more difficult to manage and, like the trees in abandoned groves, they act a reservoir for pests and diseases that can spread to properly managed orchards.

The EU's Common Agricultural Policy now recognises the value of traditional olive cultivation in rural landscapes. In the Ionian islands, for example, subsidies are available to farmers who own 'monumental olive trees' which they undertake to maintain in accordance with the old farming practices. These include traditional harvesting techniques in each region like laying cloths beneath the trees and knocking down the olives with sticks.

The EU's definition of a 'monumental' olive tree is complicated, but includes centuries-old trees with a circumference of more than 5 metres at 1.3 metres from the base. Allowance is made for trees whose centre has decayed away and those whose importance is linked to their historical, cultural or religious significance in the area where they grow. In Italy, the criteria also include the shape of an olive tree, its ecological value and its position in the landscape. The listing of monumental trees is linked to conservation schemes, backed by public funding. Separate grants are sometimes available for the maintenance of olive groves planted in old terraces.

In most Mediterranean countries, remarkable trees are now protected by law. The hoary old olive tree you see by the wayside in Cáceres or Paxos, dripping with grey leaves on pendulous branches, is almost certainly afforded legal protection by its beauty and its importance to the wider landscape. This is not a modern phenomenon, however, as individual landowners have for centuries preserved trees that they valued for more than their economic importance. Legal protection existed in ancient Athens, where olive trees on the Acropolis were considered sacred. They were descendants of the original tree given by the goddess Pallas Athene to the people who chose her as their patron and guardian. And, in most countries now, ancient trees can no longer be uprooted and sold to beautify a model garden at the Chelsea Flower Show.

The widespread planting in recent years of successful cultivars like Picual and Arbequina may lead to the extinction of varieties of historic importance and genetic potential. Some 2,000 olive cultivars grow in Mediterranean countries. Many are local varieties – relics of the past perhaps – but each contains material that made them worth growing in the first place. Critics aver that we are now planting too many trees of too few varieties. They call it 'genetic erosion'. The solution to the problem is conservation; our heritage cultivars need to be preserved, cultivated and studied for their intrinsic value and for their potential for obtaining new and better varieties.

Córdoba's Olive Germplasm Bank was established in 1970 to collect olive cultivars, first from Spain and then from all over the world. It was the model for the International Olive Council's initiative in 1994 to establish a network of olive gene-banks in the countries of the European Union. This network has gradually expanded to a total of 23 banks from all over the world, hosting over 1,700 varieties, many of them rare and local. Four of these banks are international collections (Córdoba, Marrakech, Izmir and Cosenza), and some include *ex situ* collections of promising oleasters chosen from sites with unusual ecological conditions.

Most of these collections are attached to research institutes where the cultivars can be studied and evaluated. Catalonia's Institut de Recerca i Tecnologia Agroalimentàries at Mas de Bover, for example, assesses its cultivars for the quality and the quantity of oil each produces. Several historic cultivars have been singled out for their future potential; each carries genes that may be valuable for the future olive-growing. And the National Gene Bank of Tunisia at Sfax has released five new cultivars bred from crosses between the indigenous Chemlali and Chetoui olives and the French dual-purpose Lucques.

The widespread planting of a limited number of cultivars – most especially of Arbequina clones in modern high-density plantations – may increase the danger of new diseases and pests emerging. *Xylella fastidio-*

sa subsp. *pauca* is a bacterium that has devastated olive-growing in southern Italy and its range is still expanding. The germplasm of both cultivated olives and oleasters is being sifted for genes that might provide natural resistance to the pathogen. The question that then arises is whether these can be combined with the DNA of established commercial olive cultivars without substantial loss of quality or quantity. Olives are also at risk from a future mutation of soil-borne Verticillium wilt. The hunt has begun for wild oleasters that can quickly be propagated as rootstocks for cultivated olives that might be affected in future

The future of olive-growing may come to depend upon harnessing the genetic potential among oleasters. In the past, they have been used to increase productivity and regular cropping, but it is their resilience and adaptation to adverse conditions that make them attractive in a breeding programme. Some may have useful attributes like increased resistance to cold, better tolerance of drought or the ability to grow in soils where other olives will not survive. Cultivar collections need to identify and conserve oleasters that represent a genetic advantage for the future.

Alongside the desire to protect olive landscapes and valorise old cultivars is a movement to conserve the old ways of extracting olive oil. There is no shortage of museums where the ancient methods can be seen. Presses with heavy wooden beams and huge stone wheels to pound the mash are shoved into new museums or re-erected in conspicuous places like urban roundabouts as if they were sculptural installations. Sometimes they may suggest that this is how oil is still extracted today. And some visitors, new owners of olive groves, may even decide to copy those laborious, unhygienic and inefficient processes. Olive tourism is a growing industry in countries around the Mediterranean. Mills, museums, foundations and ancient groves are brought together to create travel itineraries. Their principal purpose is educational, but most of them also have shops where every imaginable olive-related souvenir is sold.

Traditional methods of extraction continue in places where modern equipment is beyond the growers' financial capability. Moroccan maâsras are now becoming a tourist attraction and Turkey has now secured recognition for its traditional olive cultivation on UNESCO's List of Intangible Cultural Heritage. The olives are placed in a stone trough that houses the grindstone, which is turned by a donkey walking round and round to crush the olives. The pulp is then spread in baskets, called *scourtins*, made of esparto grass, which are stacked up under the press. The liquid flows into a trough that leads to a tank where it is left to settle. The oil and water from the olives separate and the oil is then stored in earthenware jars or even plastic jugs. It is worth asking whether we are wise to conserve these labour-hungry practices. Old wheels and old presses are acceptable, but modern slavery is not.

Olive wood

In ancient Greece, timber of the wild olive was valued in shipbuilding because it was proof against decay, and not affected by shipworm. In his *De Architectura*, Vitruvius described of the use of charred olive wood to tie city walls to their foundations because it was:

> "A material which neither decay, nor the weather, nor time can harm and, even though buried in the earth or set in the water, it keeps sound and useful forever."[1]

Olive wood is among the world's most compact, close-grained and hardest. Sculptors and wood-turners love its heaviness, its strength and its density, but it is expensive to buy and is seldom available in large pieces. It emits a very distinct sweet and fruity scent when being worked. Some people say this reminds them of the smell of Bay Rum. The wood is easy to polish and gives a smooth, cool touch.

The texture of carved olive-wood is very fine and gives it a natural resistance to cracks and deformations. Because of the twisting, irregular way that the tree makes its growth, the grain is immensely variable. Every piece has a unique and spectacular pattern of contrasting lines and streaks. Its colour varies from light yellow to dark brown with green or black veins that may be broad or fine. The colour may also vary according to the cultivar of the wood. Spanish woodworkers say that the wood of Picual trees from Andalusia is generally darker, with more brown and reddish tones, while Farga wood from the lower Ebro is lighter, with a base of beige or café-au-lait, finely veined with darker tints. In short, there is an infinite number of colours, tints and shades.

Olive wood is both durable and beautiful. It is also water- and stain-resistant and contains natural oils that prevent the growth of bacteria and fungi. These qualities make it a natural choice for kitchenware. Small pieces may be turned into handles, spoons or spatulas, and larger sections fashioned as cutting boards, but the most spectacular use of a larger piece of olive wood is to turn it into bowls that display the beauty of the grain.

Olive wood is usually too expensive to be used in construction work and, in damp conditions, may be susceptible to termites. However, it can be treated to prevent such infestations and then used for agricultural purposes like fencing. In parts of Spain, olive wood is cut to make high-quality gateways where the irregular shapes of its sawn and polished planks impart a rustic elegance. It also has a high combustion temperature and burns even when wet.

Man cleaning his teeth with a twig from an olive tree, Axum (Ethiopia)

1 Vitruvio, *The ten books on Architecture*

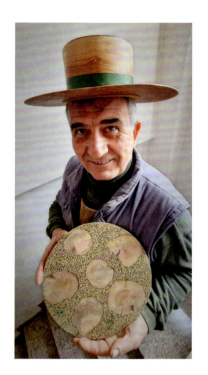

Juan, so sad to see the century-old olive trees pulled up that he decided to give the wood a new lease of life, Torreperejil, Jaén (Spain)

Mention should also be made of *Olea europaea* subsp. *cuspidata*, the olive that is native to much of East Africa and southern Asia. Its fruit have no value for food or oil but it is highly regarded for its hard and durable wood. And the African species *Olea capensis* is sometimes known as black ironwood, which gives an idea of its strength and density. It is very hard, fine grained, and dense – one of the world's heaviest – and so that some pieces sink in water.

The wood of an olive tree also has acquired a spiritual quality. When King Solomon built his gilded temple in Jerusalem, he installed a wide door of olive wood at the entrance to the sanctuary. Cherubs were carved from olive wood and placed inside it, each 10 cubits high, which is thought to equate to about 4.5 metres. For the entrance to the inner sanctuary he prescribed two olive-wood doors carved with cherubim, palm trees and open flowers, overlaid with hammered gold. Today, in Christian countries, olive wood is often used for crucifixes and sculptures of Jesus, Mary and the Saints.

Gate made from *acebuche* wood, Menorca (Spain)

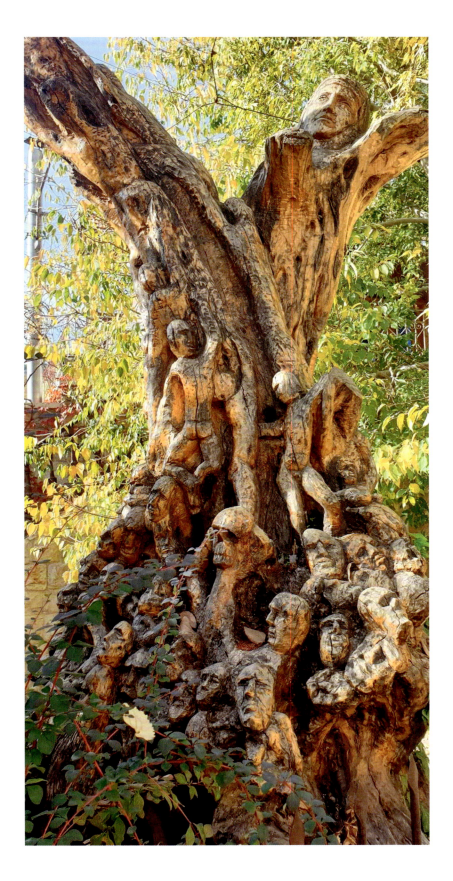

Wood made art,
Bechmizzine (Lebanon)

**Soap manufacturing,
Aleppo (Syria)**

Soap

Soap has been made in Syria and Lebanon for at least two thousand years and, in both countries, visiting a soap-maker is still a draw for tourists. Olive oil is hydrolised by soda and, traditionally, bay leaves are added to give a pleasant scent to the resulting soap. Fine soapworks have been developed in other countries, most notably in France where they were well-established in Marseilles by the 14th century. French soaps were appreciated all over the world and reached their peak of popularity in the mid-20th century, before the invention of detergents brought about the complete collapse of the Marseilles industry. A small soap industry still exists in southern France, as well as in Greece and Turkey.

Soap-making is still the ultimate destiny of much low-quality oil – pomace extracted from the dregs of the olive paste and lampante – even from countries like Spain, whose olive oil is generally of high quality. Visit an olive museum in Majorca and you will be told with pride that their island's olive oil was so delicious, so deeply appreciated by French connoisseurs, that they exported large volumes to merchants from Marseilles.

**Soap manufacturing,
Marseilles (France)**

The cretan diet

Much is written about the Mediterranean or 'Cretan' Diet. Some of it is true.

In the 1950s and 1960s, the American physiologist Ancel Keys studied the diets of 15 groups of people from seven different countries around the world. He wanted to discover a correlation between blood cholesterol level and coronary heart disease. The group with the lowest incidence of both conditions came from the country people in Crete. Dr Keys then sought to explain the low levels of mortality among these peasant farmers. He surmised that a largely vegetarian diet of fruit, vegetable, whole grains, legumes, nuts and olive oil, supplemented by a little fish and rather less meat, explained the relative longevity of Cretans. Keys's later work, and that of his disciples, focused on olive oil as the basis for a long and healthy life.

Many claims are made for the health benefits of consuming olives and olive oil. Olive oil helps to prevent the formation of blood clots and platelet aggregation. It therefore reduces the risk of developing heart disease, and helps victims of a heart attack to avoid a recurrence. Olive oil lowers the levels of total blood cholesterol, low-density lipoproteins and triglycerides. It is also an anti-oxidant whose effect is transferred to human cells which then deteriorate more slowly and increase longevity. And, though the exact reasons are not understood, the regular consumption of extra virgin olive oil appears to lower both systolic and diastolic blood pressure.

White olives or leucocarpa, Wardija (Malta)

Many more claims for the benefits of olive oil have since been made: it prevents cancers, it delays the onset of diabetes, it acts against osteoporosis and it works against loss of memory, cognitive decline, dementia and Alzheimer's disease in the elderly. Some of these claims should be heard with a measure of healthy scepticism. In any case, they apply largely to fresh extra-virgin olive oil and not to the virgin oil that Cretan persons used in the 1950s. And the benefits cannot be claimed for oil that has been refined or used for cooking. Heat destroys many of the phenols and other useful compounds in olive oil.

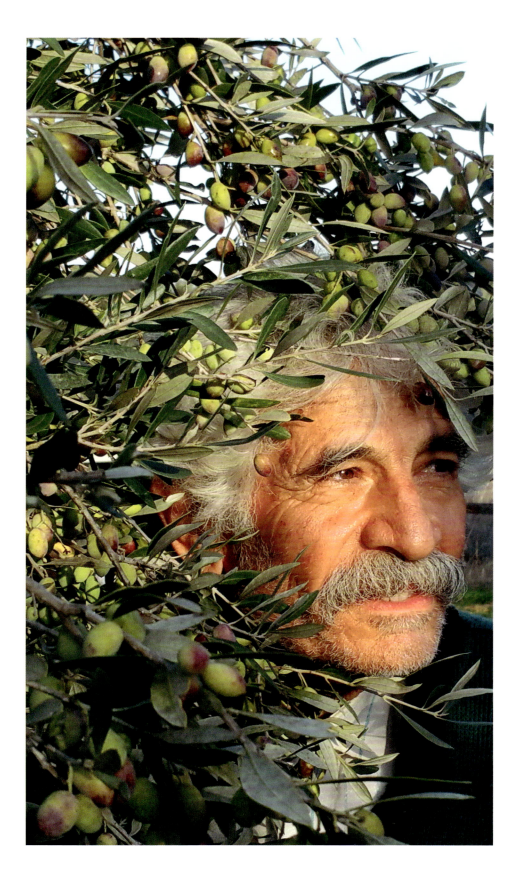

Keys's argument has been challenged on several counts. One is that he took no account of sugar as a possible contributor to coronary heart disease. Another is that France has low rates of heart disease but a diet based on meat and animal fats – a contradiction that continues to intrigue dieticians.

All are agreed that modern Cretans cannot expect the same benefits as their ancestors; they are as addicted to unhealthy foodstuffs as the rest of us. But the experiments have been done, and the data is incontrovertible: olive oil is an essential part of a diet which protects against illness and delivers longevity. A recent epidemiological study in Albania confirmed a much lower mortality from cardiovascular disease along the coastline where olives and olive oil are part of the everyday diet than in the mountainous north-east of the country where animal fats dominate consumption.

Ancel Keys retired to Italy on the proceeds of his publications about diet. He chose to live at Pioppi, a seaside town in the olive-rich Cilento region, until he was aged 94. When he died, back in the United States, he was two months short of 101.

Mr Kokolaki,
a Cretan olive-grower

The olive lifestyle

It is said that people in parts of Australia and the United States consider Mediterranean landscapes as an ideal they would like to copy. It is part of a greater fantasy – the Mediterranean Dream. Italian cypresses and rows of wine-grapes are part of the vision but, most of all, the symbol of the olive tree.

The large, potted olive trees that can now be bought from nurseries and garden centres are often a consequence of commercial imperative. As soon as the productivity of an individual tree declines, the farmer will want to replace it. It will not be old and venerable – probably no more than 80 years old, depending on the variety – and, until recently it would probably have been cut down and burnt. However, there is now a market for such trees in private gardens and public spaces. Olive trees have a shallow root system that makes them relatively easy to lift and transport. And they re-establish quickly in their new positions. The effect of repeated pruning, aimed at maintaining a manageable crown for easier harvesting, results in trunks that are squat, contorted and fissured. Their craggy beauty is ideal for garden-owners who wish to create a sense of history or to suggest that their property is older and perhaps more Mediterranean than it is in truth.

Younger olive trees are also appreciated for their ornamental effect. Cultivars like Swan Hill and Wilsonii never set fruit, so that houseproud owners are not troubled by messy falling fruit. Another sterile cultivar is Montra, which has the further advantage of never growing taller than two metres. Its silvery evergreen leaves combine well with roses and other shrubs in mixed borders. Smaller plants can be arranged and clipped into hedges, creating a drought-proof alternative to *Buxus*. Olive trees are very tolerant of hard pruning, so topiary shapes are now widely available, as well as bonsai. And young trees in pots are useful for difficult sites like rooftop gardens where heat and light are problems that olive trees can manage.

Olive trees are emblems of the Mediterranean civilisation. Specimen trees are often planted in appropriate public places. In Spain, for example, olive trees are planted in the Plaza de España in Madrid and in front of the Palacio de la Moncloa. In Palma, Majorca, a large olive tree occupies the central square called Plaça de Cort in front of the Ajuntament or town hall. It was transplanted in 1999 from a farm in the Serra de Tramuntana and has produced olives every year since it arrived. It is probably about 500 years old. In Zaragoza, the capital of Aragon, plantings of the local Empeltre cultivar fill the new roundabouts in the city centre. And in the town of Mora in the Montes de Toledo, a sculpture called the olive-man is

surrounded by real olive trees, though visitors may notice that the man himself stands proudly aside while his wife and daughter pick up the fallen fruit.

The olive tree has for centuries been represented in other art forms – images on Assyrian sculpture, Ancient Greek pottery, Roman mosaics and Byzantine enamels. The culture of the Renaissance brought realism to scientific drawings and botanical studies. Olive trees are a feature of pastoral scenes in landscape painting from about 1650 onwards. Visitors from northern Europe took delight in the effect of light on the shape of olive trees and reached for their pencils and watercolours. The impressionist painters went further; for Vincent van Gogh, the olive trees around Les Baux and St-Rémy-de-Provence inspired a dozen studies in oil. For present-day seekers after the Mediterranean Dream, a photograph of ancient olive trees by Eduardo Mencos is enough to evoke every fascination that this tree holds for us.

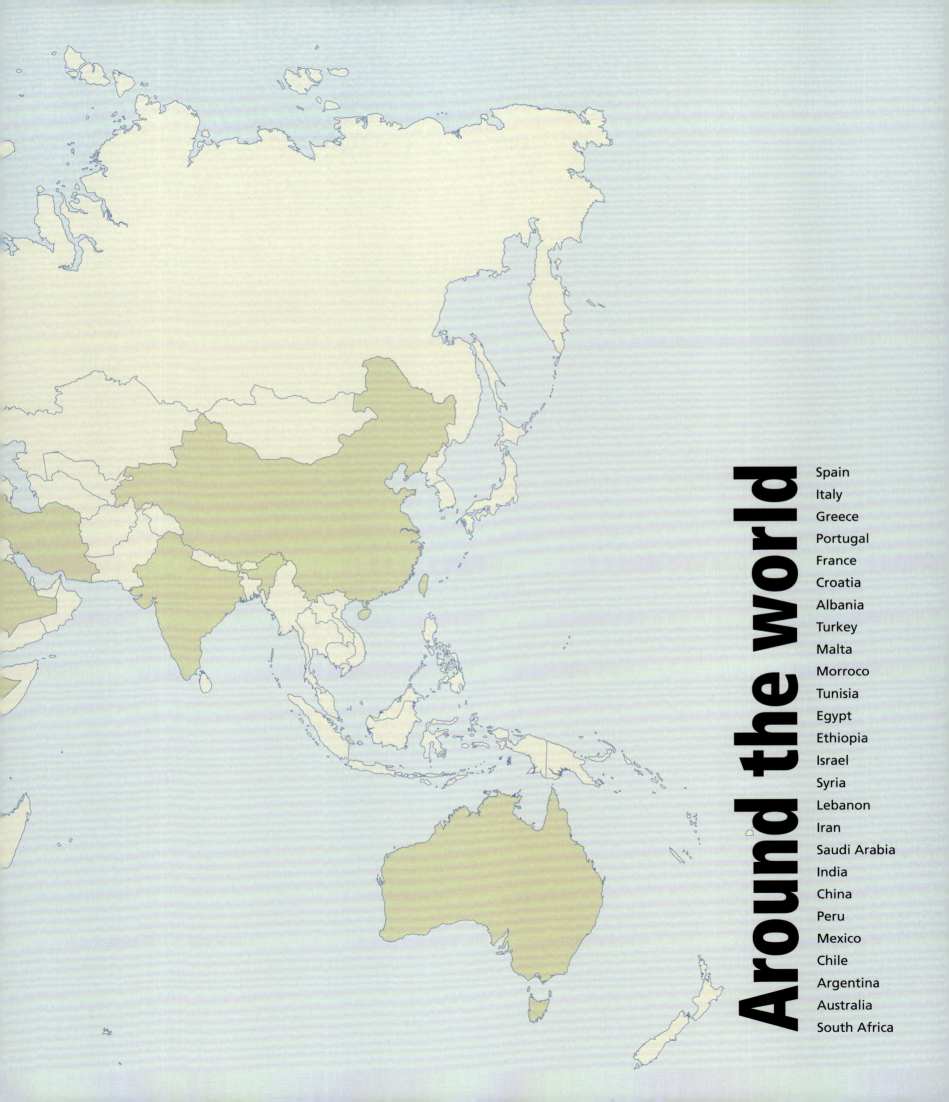

Around the world

Spain
Italy
Greece
Portugal
France
Croatia
Albania
Turkey
Malta
Morroco
Tunisia
Egypt
Ethiopia
Israel
Syria
Lebanon
Iran
Saudi Arabia
India
China
Peru
Mexico
Chile
Argentina
Australia
South Africa

Europe

Europe leads the world in the cultivation of olive trees. Europeans enjoy political stability, efficient transport, easily available technology, finance whenever required, wealth, good education and social mobility. A series of agrarian revolutions have brought new thinking and new technologies to improving quantity and quality in the production of olives and olive oil. The European Union supervises the system of Protected Designation of Origin (PDO), supports the International Olive Council in Madrid, subsidises investment in olive-growing and gives financial aid when necessary.

The most recent survey of EU agriculture in 2017 (an update is due) showed that olive trees accounted for about 4.6 million ha. Eight Member States had olive tree areas that exceeded the 1,000-ha threshold for inclusion in the survey. Spain (55%) and Italy (23%) accounted for over three-quarters of the total EU area under olive trees, followed by Greece (15%) and Portugal (7%). The four other olive-producing Member States covered by the survey (France, Croatia, Cyprus and Slovenia) together accounted for less than 1% of the EU total olive tree area.

Most of the EU's olive trees are old and nearly 2.5 million ha are planted with olive trees that are at least 50 years old. However, the recent growth in high-intensity plantations is expected to show a considerable change to these figures when they are published later in 2024. Quality and quantity will continue to improve.

Spain

¡Viejos olivos sedientos
bajo el claro sol del día,
olivares polvorientos
del campo de Andalucía!
¡El campo andaluz, peinado
por el sol canicular,
de loma en loma rayado
de olivar y de olivar!

[Antonio Machado, 1936]

Spain dominates the world of olives. Spanish agriculture is the most efficient in Europe. Spain has more olive trees than any other country. Its industry is the powerhouse of olive oil production and of table olive consumption both in Europe and around the world. Its success is founded on active government support, a powerful banking sector, a country-wide cooperative movement, a vigorous agri-food sector and aggressive business management.

Wild olive trees grow naturally in Spain. They are probably descendants of Bronze-Age efforts to cultivate olive trees for their fruit. The Phoenicians brought some of their best cultivars to the Spanish coasts between 1,000 and 800 BC. Gordal Sevillana has been the principal table olive in Spain ever since. And crosses with local olives gave rise to most of the cultivars that are grown for olive oil today. Imperial Rome looked to its province of Hispania Bætica to supply the empire with olive oil. Over the centuries, thousands – perhaps millions – of great earthenware jars were shipped down the Guadalquivir and Guardiana rivers and thence to Rome itself. The much-travelled Greek geographer Strabo wrote in about 10 AD that "large quantities of corn and wine are exported… besides much oil of the first quality." Olive-growing was also well-established in Roman times in parts of Extremadura, Valencia and Catalonia.

The Berbers and Arabs who occupied the peninsula in the 8th century brought new techniques of cultivation, notably irrigation, and perhaps also new olive cultivars. The Koran exalts the virtues of olive oil and the Arab rulers of Spain regarded the olive trees they inherited from the Christians as a benefit of conquest to enjoy and sustain. And olive oil continued to have value as a commodity for export. No fewer than thirty mills operated in the area around Seville and Muhammed Al-Idrisi, writing at the time, mentions that the wealth of the inhabitants of Seville was largely due to the foreign demand for its olive oil. The Arab legacy lives on in such words as *aceituna* and *almazara* – olive and olive-mill –which derive from the Arabic language.

Seville remained the principal area for olive-growing until the 18th century, when cultivation began to extend up the Guadalquivir valley as far as Córdoba. Wheat and vines were put aside in favour of more profitable olive trees – a process that continues today in all parts of Spain where crops are not artificially irrigated. But not until the 1930s did the area of olives in Córdoba and Jaén overtake Seville. Spain's refusal to get involved in the Second World War stabilised the country so that the whole agriculture sector grew steadily right through to the end of the 20th century. The monoculture of olives in those two provinces is therefore a recent phenomenon. This expansion continues today as a result of the mechanisation of farming, increased world demand, the arrival of intensive and super-intensive models, and the industrialisation of production.

The olive landscapes of Spain – especially the immense 'sea of olive trees' in Andalusia – are one of the country's great attractions. Jaén is the centre of the world olive industry. The sheer size of its plantations is staggering: lines of Picual olive trees rise and fall with the lie of the land and cross-hatch the hill-tops as far as the eye can see. The tourist's vision of the Spanish countryside is a black bull from Osborne on the crest of a hillside of olive trees. But olive trees are also iconic symbols of the country's history and rural economy. Spain's olive groves are immensely valuable and dramatic symbols of its landscapes and heritage.

Cooperation between farmers has been at the heart of most forms of agricultural activity in Spain since at least the 1940s. Olive mills, usually owned by cooperatives, are central to the olive industry in Spain. Every village has at least one and its buildings are often the largest in the area. All have modern systems of extraction and storage.

Throughout Spain, innumerable olive groves are owned or occupied by smallholders who combine olive-growing with the cultivation of other fruits, animal husbandry and market gardening, much of it only at subsistence level. Cooperatives offer advice on cultivation and harvesting, which helps to preserve groves in marginal areas. Poor soils and steep slopes are increasingly under threat because they are difficult to cultivate and do not earn enough to encourage younger family members to commit to the farming life. Without the support of their cooperative, many growers would abandon their olive groves. This would quickly lead to a degrading of the landscape. EU subsidies provide essential help to small farmers but the level of support they receive from the Common Agricultural Policy differs between regions; the lion's share goes to Andalusia, to the detriment of regions where olive-growing is less conspicuous.

Cooperatives are encouraged to find partners for possible mergers. There are groups of cooperatives now working together as secondary cooperatives and, for some years now, tertiary cooperatives too. Secondary and tertiary cooperatives can negotiate better pricing from the blenders, the companies that buy in bulk,

then bottle their oils and fill the supermarket shelves. Large cooperatives that sell their oil at higher prices can also buy fertilisers, plant protection and machinery at greater discounts. The Cooperativa Nuestra Señora del Pilar at Villacarrilo in Jaén has 14 production lines.

Spanish oil is not always of the highest quality: some 30% is lampante and needs rectification before it can be blended and consumed. A typical area like Valencia's Maestrat has large quantities of low-quality oil – as much as 70% of it lampante – that ends up in the supermarket blends created by large agro-industries. But the Maestrat is also typical because this substandard oil is produced alongside good extra virgin oil, sometimes organic or single-variety, made by enterprising individual farmers using the equipment of the same cooperatives. The success of individual estates throughout Spain, including Castillo de Cañena, Marqués de Griñon and the long-established Núñez de Prado, has set a precedent for high-quality oil to be bottled in Spain and sold abroad as upmarket choices.

Some 55-60% of Spanish olive oil is exported to other countries in Europe. Most of it is extra virgin and sold in bulk – about half of it to Italy. Andalusia accounts for 75-80% of the national production, with perhaps 8% in Castille-La Mancha, 5% in Extremadura and 3% in Catalonia. Production is increasing and domestic consumption is at best stagnating or shrinking, but the industry is now geared to expanding production for an expanding export market.

Among the largest of Spain's secondary and tertiary cooperatives are Olivar de Segura, Jaencoop, Almazaras de la Subbética, Oleoestepa and Unió, but the largest in the world is DCoop. Of its 180 cooperatives, some 113 produce olive oil – about 7% of the world's total production – and it exports to almost 70 countries. Its subsidiary Mercaóleo runs four modern bottling plants which blend and pack olive oil for several brands, including Pompeian, one of the leading brands in the United States. But by far the largest exporter of olive oil, ready bottled for retail sale, is not a cooperative but a Seville-based blender called Acesur, which has 20% of Spain's home market and 15% of its exports.

Spain has 33 PDOs and 3 PGIs. Some are commercially very active; Baena and Priego de Córdoba are perhaps the two that have most obviously used the system to raise the profile and prices of its oils. In the early days, some PDOs were created to encourage growers in a particular area to improve their standards.

Some 70% of Spain's olive groves are well-established traditional plantings, half of which can be adapted to modern machinery and could in due course also be replaced by intensive or super-intensive plantations. The rest are in danger of abandonment and need subsidies to make their maintenance viable. Their loss would have far-reaching consequences for the beauty of Spain's many landscapes.

It is clear that the future lies with intensive and super-intensive growing, allied to mechanisation to increase production, reduce costs and obtain higher quality oils. Traditional cultivation will fade away and small holdings will be abandoned. The face of Spain will change in a manner that many regard as regrettable. It will be the concern of governments –regional, national and European – to reconcile economic progress and social change with the conservation of Spain's beautiful and historic landscapes.

The conservation of Spain's olive heritage is managed by the Olive World Germplasm Bank at Alameda del Obispo on the edge of the city of Córdoba. It has the largest collection of Spanish cultivars and many more from around the world. There are some 260 olive cultivars in Spain, but the most important is Picual, which is thought to date back to a local oleaster and now accounts for 60% of the land planted to olives in Andalusia. Its dependable, heavy cropping and its high yield of olive oil have won it a dominant position. Its oils contain a high level of polyphenols and enjoy a long shelf-life. In the province of Jaén, Picual accounts for 98% of all plantings in traditional groves. Its abundance does, however, put such pressure on farmers and cooperatives that trees continue to be picked well into late winter, when the quality of the oil may be difficult to sustain. It has a distinctive taste – heavy, fruity and decidedly bitter – and peppery, too, if the olives are picked young. Spaniards love it, most foreigners do not. Much of the crop ends up as a basic extra virgin oil on supermarket shelves in northern Europe. Its strong, distinctive taste is always detectable in blended oils. When Picual is grown at higher altitudes like the Sierra de Cazorla, its oils are often lighter and even refreshing.

Hojiblanca is second only to Picual in the scale of its planting in Andalusia and accounts for about one-fifth of all olive trees in the region. It is the dominant cultivar in the PDOs of Lucena and Antequera. Its dual-purpose olives are late to mature and firmly attached to the branches. It is highly regarded for its smooth, fruity oil, whose taste is unusually variable but well-balanced. Picudo is another popular dual-purpose variety, especially in the area around Baena but never the dominant cultivar. The oil is short-lived but popular because of its low bitterness and smooth taste – well-balanced, almost sweet, with hints of exotic fruits, apples and almonds.

The distribution of olive cultivars in Spain is closely allied to their place of origin. Long-lasting, smooth Cornicabra is the leading cultivar in Central Spain, especially Castilla-La Mancha. Its gentle, velvety, almost sweet taste is sometimes described as reminiscent of avocado pears. It is an old cultivar, late-cropping and represented by many slightly different clones, but its oils are very stable and will last for longer than any other widely-grown Spanish olive. The Farga olive dominates Valencia – a low-yield olive with a smooth, elegant taste. It is a very old variety with small olives but the trees are resistant to cold, which explains why so many trees are reputed to be at least 1,000 years old. Empeltre is another fine ancient variety, popular in

Aragon, Catalonia and Majorca, though its ancestry is closely linked to the Middle East. It will thrive in marginal land and is early-ripening which, combined with its regular cropping and easy picking, makes it useful for mechanised harvesting. Its oil is smooth, delicious and useful for blending.

Although Empeltre is the most widely planted olive in the Terra Alta, the most popular cultivar in the rest of Catalonia is Arbequina, now known worldwide for its regular cropping and adaptability to intensive farming. Olive trees are the most important woody crop in Catalonia and 80% is rain-irrigated, so it has not gone unnoticed that much of the region could be converted to more intensive plantings

Arbequina is an early, productive, regular cropper, whose lack of vigour makes it suitable for intensive cultivation in climates very different from its native Lérida. In Catalonia it is an intensely fruity and well-balanced oil but it has a tendency to blandness in warmer climates like Andalusia and North Africa. Its main failing is that it quickly loses its fresh flavour, unlike, for example, the Koroneiki cultivar with which it is often paired in super-intensive plantations. It is said that the original plants of Arbequina were imported to Catalonia from the Near East by the Duke of Medinaceli in the 1760s and that he promised farmers a subsidy for every tree they planted. Some Catalans claim that Arbequina was grown in Spain much earlier, but DNA analyses place its ancestry on the eastern seaboard of the Mediterranean.

Each of the olive varieties unique to Spain emerged as the best performer in its place of origin. Those that dominate Catalonia, Valencia and Castilla-La Mancha are very different from each other and, perhaps, even more different from those that have smothered the hillsides of Andalusia. The choice of table olives is not subject to regional variation. Spaniards all agree that Gordal Sevillana is the best variety for its size, juiciness and taste, though it should be added that Manzanilla Cacereña from Extremadura is also highly esteemed and widely grown.

But there is so much more to the olives and olive trees of Spain than big cooperatives, big blenders, big this, big that. One must think of the white villages of Andalusia, *los pueblos blancos* high on hills or close to streams and rivers but always swathed in olive trees. One should ponder the place names – the village called Aceituna in Cáceres, the suburb of Olivos Borrachos in the city of Seville, the Madonnas del Olivo, the olive presses dedicated to San Isidro and the Miraculous Olive Tree of Huesca. One must remember the great beauty that olive trees add to Spain's already beautiful countryside – the spacious landscapes, the Caminos de los Olivos, the infinite sense of space, the rustle of evergreen leaves in the breeze, the great heaving of branches in stronger winds, the flash of their pale undersides, the greedy flight of starlings, the clumsy glittering magpies, shy golden orioles and handsome hoopoes – thieves, all of them – but remember that they take not just the olives but also the olive flies before they lay their eggs. Eagles and vultures hover silently

overhead while noisy owls hunt and grumble at night. At midday the olive groves hum along with the orchestras of crickets and shudder at the approach of deep-droning hornets. Evening brings shrill mosquitos and all those fireflies.

Spain is the land of harvest celebrations, feasts to greet the new oils, competitions and speeches, then perhaps the singing and dancing of farmers and workers, women and children, young and old. The Mora in Toledo attracts parades and processions for its annual olive festival. Arbeca, the small upland village that gave us Arbequina olives, offers three days of rejoicing for the new harvest. Biggest of all – as one might expect – is the two-day festival in Jaén every November, with cooking demonstrations, tastings, music and fun events for children. Yes, Jaén strives to excel in every aspect of the life of olive trees, but we celebrate the thousands of villages in every region, every province of Spain, for whom the olive tree is a livelihood, a source of food and fuel, a thing of great benign beauty that governs and guards every minute of their lives.

Italy

'Oh, i bei rami d'ulivo! chi ne vuole?
Son benedetti, li ha baciati il sole.'

[Giovanni Pascoli 1855-1912].

The Spanish olive industry has great power, efficiency and dependability. Italy's, by contrast, is fragmented and rather introspective. And yet, it is to Italy that we look for unmatched oil quality and for landscapes of supreme beauty.

Olive trees were brought to southern Italy and Sicily by the Phoenicians in about 1,000 BC. Earlier Bronze-Age farmers had begun to select improved forms of oleasters. These were inter-bred, together with further cultivars that arrived from Greece after about 500 BC onwards, and are responsible for the proliferation of Italian olive cultivars.

The ancient Romans cultivated olive trees. Olive oil was a required commodity in every corner of the empire, transported in amphorae, wooden barrels and animal skins. Monte Testaccio is an artificial hill on the right bank of the Tiber, entirely composed of crushed amphorae that brought the oil to Rome. Strabo wrote that

superior to any other was the oil of Venafrum, the modern Venafro close to the point where Lazio, Molise and Campania all meet. In this, Strabo agrees with Pliny, 50 years later, who placed it above the oils of Bætica and Istria.

The demise of the Roman Empire brought the collapse of international trade in olive oil, but Christian monasteries kept alive the skills of olive culture. With the establishment of the feudal system, tenants were granted long leases that encouraged them to plant crops like olive trees. Surplus oil could be sold for food or for soap production and, by the 14th century, Venice and Genoa competed to control the market. Meanwhile, Tuscany rapidly expanded its olive-growing to supply oil for woollen cloth-makers in Italy and abroad. Olive-planting also increased along the Adriatic coast of the Papal States and Naples. Religious orders planted substantial areas with olives, not for sacramental purposes but to raise funds to protect their sanctuaries from pirates.

In 1327 Robert of Anjou exempted the Puglian town of Gallipoli from taxes on oil production. In 1427, 100 years later, farmers in the Maremma were obliged to plant two olive trees every year and to graft two more. In 16th-century Tuscany, the Medici gave tax exemptions to landowners and municipalities who planted olive trees and vineyards. In 17th-century Sardinia, the Spanish viceroy, John Vivas, decreed in 1624 that farmers who grafted wild olive trees would own the land on which they grew. Similar laws were promulgated in Calabria in 1783, together with tax exemptions for up to 40 years. The steep slopes of Liguria were thickly planted with olives by 1800 while mulberries in Tuscany were replaced by olive trees, with wheat as a catch crop between the rows. In 1830, Pope Pius VII awarded one *paul* (a day's wages) for each olive tree planted and cared for up to 18 months: between 1830 to 1840, 38,000 olive trees were planted in Umbria. The industrial revolution in England increased the demand for oil as a lubricant and in such processes as rope- and cloth-making. Livorno served as the port for Tuscan exports while Brindisi, Taranto, Gallipoli and Otranto were Naples's bases for traders, coming not just from Venice but also from Russia, Germany, the Netherlands, Austria and England. Such was the importance of olive oil that the British first established a vice-consulate at Gallipoli in the 1660s.

No country has so many varieties of olives as Italy – at least 700, even after allowing for duplicate naming. Every region has a long list of indigenous cultivars that give its oils their distinctive quality. The region of Campania, for example, has no fewer than 60 olive varieties that are unknown elsewhere, in addition to those that are interlopers from other regions like Biancolilla and Pendolino. This diversity is sanctified by the legislation that governs Italy's PDO oils (*Denominazione di Origine Protetta* in Italian). Italy's olive oils have 41 PDOs and 9 PGIs, which bolster the Italians' conviction that their own oil is better than their neighbours.

The PDO legislation also makes detailed rules about the use of olive cultivars in applications for PDO status. For example, the Monti Iblei area in south-eastern Sicily has been split into eight different collections of villages, each of which has a different list of the quantities they may contain, not just of the local cultivars Tonda Iblea and Moresca, but also of other varieties. Local growers are proud of these micro-distinctions.

Olive-growers with small holdings are well supported by cooperatives all over Italy. Most of them are very well run, ensuring that their members comply with their rules for cultivation, pruning and harvesting. As a result, they generally obtain better prices for their oils than do cooperatives in Spain. In areas where landholdings are very fragmented, the cooperatives may be the only option for growers, but they are attentive guardians of local tradition. Three of the best are Agraria Riva del Garda at the top end of Lake Garda, whose DOP Garda Trentino oil is made exclusively from the local Casaliva variety; Colli Etruschi at Blera in Viterbo whose DOP Tuscia oil is supplemented by a line in organic olive oil; and the Cooperativa Agricola Peranzana at Torremaggiore in Foggia which, as its name suggests, champions the local Peranzana olive.

The olive oil cooperatives are not as large or numerous in Italy as they are in Spain; it is estimated that they account for no more than 30% of the country's production. Italian mills are small-scale, well-equipped. modern and numerous, and nearly two-thirds are run by small family companies. This reflects the pattern of ownership – Italy has a large, prosperous agricultural and land-owning class. Both private owners and cooperatives prefer to sell their oil in bottles, emphasising the particularity of the area, the methods of cultivation or the olive varieties from which it is pressed. Most of their sales are made locally because the demand for oil from other regions is weak in Italy and the competition for foreign sales is strong. Ultimately, however, the producers have no difficulty in selling their oil because the big blenders are usually happy to buy it.

Many of the large blenders and exporters are not in olive-growing regions. Oleificio Zucchi, for example, is in Cremona. Others are more deeply rooted in their original regions: Fratelli Carli at Imperia dominates Liguria, and Farchioni, whose *Il Casolare* brand is familiar all over the world, is based in Umbria. And the giant Salov company, which owns Filippo Berio, is based in Lucca.

Italy is a nation of opinionated individuals, but they come together well when concerted effort is required. Even the most modest owners of olive trees are keen to improve the quality of their cultivation, the management of their olive grove, and their techniques of pruning, picking and transportation. Better practices mean better oil, whether for home consumption or for sale. Great attention is paid to accessing good ex-

traction machines and, later, to decanting, filtration, storage and labelling. Traceability, certification and quality are carefully overseen by the authorities

Top-quality oil is made everywhere throughout Italy. There is a high awareness among producers of the importance of selling extra virgin oils, often organic, that show off the quality and character of their olives. Trade associations like *Laudemio* in Tuscany seek to establish and sustain the reputation of their members' estates for producing consistently high-quality olive oil.

Certain cultivars have acquired international renown and are now planted outside their areas of origin and in the New World. Tuscan Frantoio for example, is grown near Lake Garda and, as Cailletier, in France. Leccino, also from Tuscany and noted for its hardiness (and, some would say, for its unexciting taste), is planted as a pioneer in such cold-winter areas as Piemonte and the Veneto, but also in warmer Puglia, where its resistance to the *Xylella fastidiosa* bacterium is noted. Both cultivars are grown in countries around the world but the taste of their oils is often very different from their fruity, peppery flavour in Arezzo and Siena where they are blended with such cultivars as Pendolino, Cipressino and Moraiolo, a variety that was almost certainly known to the Ancient Romans

Italy consumes more oil than it produces, so it may come as a surprise to learn that Italy is the second-largest olive oil exporter in the world. Italian companies buy good oils from other countries, notably Greece and Tunisia, which are blended to create a 'house' style that is consistently popular in north European and American markets. The brand names are trusted, the oil contains no hint of the unpopular taste of Spanish Picual, and the retail prices reflect the high quality of the product. Extra virgin oils from Italy carry a cachet.

Foreigners believe that the best olive oils – like the best wines, the best coffee and the best swimming pools – come from Tuscany. They could not be more wrong. Tuscany's olive oil is good, sometimes very good, and its reputation for excellence is matched by its price. There are, however, better olive oils throughout Italy – most notably from Puglia and Sicily –where quality is generally higher and prices are certainly lower. Ultimately it all comes down to cultivars: the great olive varieties of Central Italy are outclassed by the traditional cultivars of Puglia (Coratina, Cellina di Nardò and Ogliarola Salentina) and Sicily (Cerasuola, Nocellara del Belice and Tonda Iblea). The huge range of local varieties and distinctive tastes is one of the great strengths of Italy's olive industry.

No other country, not even Spain, makes so much high-quality oil as Italy, nor from so many different cultivars, each of them native to a specific area and each with a distinctive taste. That said, DNA testing has complicated the uniqueness of local Italian oils. We now know that Peranzana from Foggia is the same

cultivar as Bosana in Sardinia, and that there is no difference between Ogliarola Barese from Puglia, Correggiolo from Tuscany, and the famous Taggiasca of Liguria. The question then arises – how and when did these large-scale migrations take place? Economic historians have no answer.

The centuries-old olive trees of Pantelleria – the volcanic island best known for capers, muscat wines and illegal immigrants from North Africa – are pruned to a height of about 120 cm to protect them from the incessant wind. The islanders insist that they are a unique variety brought by the Arabs, the Greeks or, sometimes, even the Phoenicians. DNA analysis confirms that they are no more and no less than the popular and widely-planted Biancolilla variety from western Sicily.

There are millennial olive trees in every part of southern Italy. The Innari olive, near Enna in the centre of Sicily has a trunk that is 19.6 metres in circumference – experts claim that it is the Santagatese variety – and Agrigento has a famous seedling called Oleastro d'Inveges near Sciacca. It is 13 m high and reckoned to be between 700 and 800 years old. Sicily has 'monumental' olive trees in every province and Siracusa claims to have more millennials than any other

The oldest olive trees in the region of Puglia are on the Brindisi plain near Ostuni, Fasano, Monopoli and Carovigno. Some are estimated (but not proved) to be as much as 3,000 years old. Sometimes the owners have preserved them as handsome features to enjoy within the landscape, but many were cut down in the 1980s and 1990s to make way for modern plantings. The survivors are often very tall and very beautiful and nowadays all have statutory protection. Anyone who wishes to cut down an olive tree must apply for a permit that is rarely granted.

Old olive trees are also found throughout Calabria. Near Vibo Valentia, for example, is a gigantic specimen composed of two distinct varieties, thought to be the original grafted variety and a sucker from its rootstock. It is known as the 'du' mani' – or 'two hands' in the local dialect.

The oldest olive trees in Tuscany are near the coast in the area around Capalbio, in the province of Grosseto. Tuscans like to suggest that they were originally planted by the Etruscans, though it is unlikely that any have survived for so long. Cold winters have frequently devastated Tuscan olive trees, notably in 1929, 1956 and, 1985. Trees are killed to the ground and must then regenerate from the roots. Climate change has enabled olive trees to be grown in parts of northern Italy like Piemonte – especially Monferrato – where they were not seen before. However, rising temperatures and droughts have also made olive-growing more difficult in some southern areas where they have for centuries been a major feature of the agricultural landscape.

It might be said that the culture of the olive tree runs deeper in Italy than in any other country. Your taxi driver will tell you the exact levels of acidity in this year's crop (naturally, his own are the lowest) and explain just why everyone from his *comune* wins prizes at national and international shows. But his pride extends to the excellence of Italian wine, Italian food and Italian coffee – perhaps even to the superiority of Italian swimming pools.

Greece

γλαυκάς παιδοτροφόυ φύλλον ελαίας΄

[Sophocles]

The Greeks never cease to extol their olive oil – its taste, its quality, and its health benefits, as well as it uses in the kitchen. And they cure their olives – an essential part of Greek cooking – in many more ways than any other country.

Fossilised olive branches have been found on Santorini, dating back 60,000 years. It is, however, generally agreed that olive trees were cultivated in Crete by about 2,500 BC and that they spread from Crete to much of the rest of the Greece over the next 1,000 years. The later expansion of Greek and Phoenician colonies all over the Mediterranean brought the cultivation of olives and the culture that grew up around olive trees as far as France and parts of Spain.

Legends quickly developed about the origins of the olive tree, the source of nourishment, medicine and fuel. Athenians knew that it arrived as a gift from Pallas Athena, goddess of Wisdom who became the patron and guardian of the city. Olive trees were sacred for ever after and the original olive plant survived on Athens's acropolis for nearly 1,000 years. Cutting down an olive tree was punishable by exile or even by death.

In the original Olympic Games, the victors were crowned with wreaths of olive twigs cut from sacred wild olives on Mount Olympus. When the Olympic Games were hosted in Athens in 2004, it was decided that the winner of the Marathon race would be crowned with a wreath of olives. Since Zeus's wild olives were now extinct, the wreaths would come not from Mount Olympus but from the oldest tree in Greece. It came as no surprise that there were two trees in Crete which claimed to be the most ancient, one at

Kolymvári near Chanía and the other at Kavoúrsio in Lasíthi. However, no-one could agree which tree was the oldest, so the tree at Kolymvári provided leaves for the men's Marathon and the one from Kavoúrsio for the women's race.

Olive trees are everywhere to be seen in Greece today, except on the highest mountains of the Peloponnese and inland uplands of Macedonia and Thessaly. It is hard to imagine a Greek landscape without them. Some of Greece's best-known sites, including the sacred precinct at Delphi and the Frankish castle at Amphissa, are surrounded by olive trees. Olive trees are especially thickly planted in Crete, in parts of the Peloponnese, in the Ionian islands and on the Aegean Island of Lesbos. More than 100 cultivars grow in the National Olive Research Institute in Chania in Crete, but only some 20 are widely planted and, even then, only locally – Manaki in the Argolid peninsula, for example, or Valanolia on Lesbos. These old cultivars were developed over the centuries as the most suitable and dependable choices for their localities.

In the 1960s, however, the Greek government encouraged farmers to plant a cultivar called Koroneiki, from Koróni on the western side of the Gulf of Messinia. More than one million trees were planted each year between 1961 and 1966. Koroneiki was indeed superior in many ways to other traditional Greek olives. It was easy to propagate and grow, drought-tolerant and self-fertile – a regular and copious cropper whose oil is consistently of high quality, robust and fruity, with a well-balanced bitterness and a strong, peppery finish. And its high content of anti-oxidising phenols means that it keeps its fresh taste for much longer than most oils. Large numbers of traditional cultivars were uprooted and replaced by Koroneiki. Today, an estimated 60% of all olives trees in Greece are of this one variety but, thanks to its consistent quality, some 80% of Greece's olive oil is now extra virgin.

One upshot of the widespread planting of Koroneiki has been that oils made from other Greek varieties, each with its history and taste, are increasingly blended with Koroneiki and losing their distinctive character. The stability and fruitiness of Koroneiki makes it particularly suitable as an oil for blending and it has brought about a regrettable situation where much of Greece's olive oil is now sold in bulk to Italy at low prices, where it is mixed with Italian oils (of inferior quality, say the Greeks) and sold at a high mark-up in supermarkets across Europe with smart Italian labels.

Greece always has a surplus of oil that must be exported, but the size of that surplus varies. Every year, Italian negotiators descend on the cooperatives and private consortia that have large stocks to sell and seek to secure their required volumes. The prices they pay are less than these Koroneiki oils merit and sometimes the small farmers who grow the olives suspect that the Italians pay bribes and backhanders to the Greek bosses. Koroneiki is not perfect, and its monoculture creates a sameness among its oils. It has its weaknesses, too:

Koroneiki may be nicely fruity and neatly balanced, but it is also short on real flavour. It cannot match Catalonia's Arbequina or Sicily's Nocellara del Belice for taste – or for the intensity of their fruitiness.

When the Greek government began to promote Koroneiki for their dependable oils, it also encouraged farmers to plant Kalamata olives – another variety native to the Messinia peninsula, originally from Kalamon. These are now the best-known Greek olives abroad – shiny, black, tight-skinned, meaty and slightly bitter. They have the advantage of being 'free-stone', which means that the stone is not attached to the surrounding flesh but can easily be detached when eaten raw.

The importance of Kalamata olives for the domestic market is completely outshone by great quantities of the variety called Conservolia, which accounts for 80% of production and is grown more or less everywhere in Greece, from Thessaly to Rhodes. Most highly esteemed among the Greeks themselves are the Throumba olives from the most northern island of Thassos. Their tolerance of the *Phoma oleae* fungus removes their bitterness if they are allowed to stay on the tree until late winter, by which time they have a distinctively wrinkled skin.

The Aegean Island most completely given over to olive-growing is Mytilene – better known outside Greece as Lesbos. It is a large island, and the olive trees cover 79% of the cultivable land, more than anywhere else in the world. Walking through the island is a unique experience – an endless forest of mature, silver-green olive trees, many of them grown on old terraced hillsides. The olive oil market in Lesbos was well established in Ottoman days. However, the great frost of 10 January 1850 destroyed all the island's olive trees and the inhabitants – those not forced by the disaster to emigrate – decided to replace them with hardier cultivars from elsewhere and to expand the area given to olive-growing. Now the island's olives are 65% Valanolia (here called Kolovi) and 30% Adramytiani. The remaining 5% are old varieties that eventually came up from the roots of trees that were thought to have died in 1850. Lesbos olives are picked late and yield an oil that is golden-yellow, fluid and aromatic, with a soft, smooth, ripe taste. Many of the island's olive trees look very old – their rugged trunks suggest that they were planted perhaps as much as 500 or 600 years ago – but we know that none of them was planted before 1860.

Olive growing in Greece is in essence still a small-farm enterprise and the family holdings of land and olive trees are often less than two hectares in size. Some are increasingly neglected and reverting to Nature. As in Spain, owners are supported by agricultural cooperatives whose insistence on high standards of cultivation increases the quality – and hence the value – of the finished product. The benefits are not always fully appreciated by the farmers, who often convince themselves that their own oil is of such exceptional quality that it would be an international money-spinner if only it were separately bottled and sold.

The Venetians cultivated olives in Crete and the Ionian Islands and controlled their trade with northern Europe. Beautiful ancient olive-trees still survive; Corfu's groves at Epikepsí, Nýmfes and the Rópas valley are particularly fine. High rainfall guarantees good regular cropping for the endemic Lianolia Kerkyras olives, though here, as throughout Greece, too many modern plantings are high-density groves of the ubiquitous Koroneiki.

The great majority of olive trees in Crete are also of Koroneiki now. Old groves with large ancient trees have been grubbed-out and replaced by intensive plantations, often with drip irrigation to increase the yields. The traditional cultivars are still planted in Crete but only as pollinators or at higher altitudes where Koroneiki does not flourish. Mastoides, here called Tsounati, still has a following in the west of the island and some investors are rediscovering its virtues. Early-harvested Tsounáti oil has a delicious, fresh taste of almonds, artichoke and grassiness, and a lingering aftertaste.

Greek olive oil is not just for export. Greeks are variously estimated to consume annually between 15 and 22 kilos of oil per person. Whatever the correct figure, all agree that per capita consumption in Crete stands at 27 kilos. Cretans ascribe their traditional health and longevity in part to the beneficial properties of consuming large quantities of extra virgin olive oil. There is no such thing, they insist, as a Mediterranean Diet – just the Cretan Diet.

Portugal

'Oliveiras cor de luto

Dão azeite cor de mel

Também os livros dão fruto

Entre folhas de papel.'

[Dom Francisco Moreira das Neves 1906 -1992]

Cultivated olives arrived in Portugal with the Phoenicians – up the River Guardiana into the Algarve. By the time of the Roman Empire, Lusitania was exporting large quantities of olive oil to Rome, as did the Bæticans of modern Andalusia. Cultivation had by then extended up into the Alentejo but was generally sent through the southern ports of Faro, Tavira and Castro Marim. Its reputation for quality was high, and continued after

the collapse of Roman Empire and the rule of the Visigoths. The Portuguese like to recall that when the laws of their conquerors were merged with Roman law and promulgated as the Visigothic Code in 654, the provisions designed to protect agriculture prescribed a fine of three *sous* for anyone who uprooted a person's tree, rising to five *sous* if the tree was an olive.

During the Arab occupation, the cultivation of olive trees was improved by the introduction of fertilising and irrigation. The Algarve remained the most intensely cultivated part of western Iberia and some of the oldest trees in the country, particularly around Tavira, may date back to these times. Oil was exported to the Almohad caliphates in North Africa and the Portuguese word for olive oil – *azeite* – is derived from the Arabic word *az-zait*. During this period, and the long years of the Reconquista, olives continued to play an important part in the Portuguese economy and oil was exported to northern Europe. After the discovery of America and the establishment of colonies and trading posts in the Far East, wine and oil were major Portuguese exports – a situation that still exists and is seen in the large quantities of Portuguese olive oil sold to Brazil.

By the start of the 20th century, olive trees were grown throughout Portugal and a great number of local cultivars were used to create distinctive olive oils and *azeitonas* or table olives. These have since been enshrined in six PDOs, Protected Designations Of Origin. Three are from the Alentejo – Norte Alentejano, Alentejo Interior and Azeite de Moura. Moura has long enjoyed a reputation for good olive oil: there is a Portuguese saying *tão fino como o azeite de Moura*. The other three PDOs are Trás-os-Montes, Beira Interior and Ribatejo. Ribatejo was once the leading region for Portuguese olive oil. Santarém has been known for its oil since at least the 13th century and the area around Tomar is famous for its traditional Easter *bolos de azeite*. These are joined by two PDOs for olives – Negrinha de Freixo from around Bragança and Guarda which, despite their name, can be green or black depending on when they are picked, and Elvas e Campo Maior, which are usually brined when still green. In the Algarve, but not protected by a PDO, the local cracked olives known as Maçanilha Algarvia are picked green, in September, and soaked in fresh water every day for up to two weeks.

In 1986, when it joined the EEC, Portugal had 340,000 hectares of olive groves with the highest numbers in Alentejo and Trás-os-Montes and, because so much of its own olive oil was exported to Brazil, the country was a net importer of olive oil. It was a very traditional industry, uncompetitive and burdened by the cost of manual harvesting. Trás-os-Montes is still the second most important olive-growing region in the country; the trees are widely spaced and traditionally grown, often alongside vines, where they contribute considerably to the splendour of the countryside. This is a region of mountains and shale uplands, rugged but intensely beautiful. In autumn, the olive harvest coincides with the changing colours of the vines of the Upper Douro – a superb and unforgettable scene.

The spacious landscapes of the empty Alentejo have disappeared. In place of cork oaks and cereals, the countryside is covered by extensive intensive and super-intensive olive groves. There are now more than 50,000 hectares of super-intensive plantations, irrigated by water from the Alqueva reservoir – Europe's largest man-made lake, originally rather controversial, created by damming the Guardiana. Now three-quarters of Portugal's olive oil production comes from Alentejo and the country is a net exporter of oil; many of the large producers sell in bulk to Spanish and Italian brands. Such has been this expansion that Portugal is expected soon to overtake Greece as the world's third-largest producer of olive oil.

Investment in this transformation of the Alentejo region came partly from Spain, driven by the flight of capital following the 2008 financial crisis, and partly from Sovena, Portugal's leading agricultural multinational which now has extensive investments in olive groves also in Spain, Morocco and Tunisia. Most of the super-intensive plantings are of Arbequina while the intensive plantings are of Picual, Andalusia's wonder-olive. But there is also a demand for oils made from traditional olive cultivars – notably Galega, Cordovil de Serpa, Verdeal Alentejana and Cobrançosa – which are now enjoying a revival of investment leading to good cultivation and high-quality production. Country folk make their breakfast from olives on bread, seasoned by salt, oil and marjoram

Galega is the most important of Portugal's heritage olive cultivars and used to account for 80% of plantings before the invasion of foreigners like Arbequina. It is one of those varieties that are firmly attached to the tree and hard to dislodge. Finding enough people for the harvest is always a problem with traditional olive groves where the young people have moved to urban areas. If it is picked when green, Galega yields a stable, long-lived, fruity oil with a hint of bitterness but this is not a taste that appeals to the important Brazilian market. The Galega oil that is exported to Portugal's former colony is made when the olives are fully ripe, so that it is sweet and soft with a suggestion of almonds and dried fruit, and no trace of bitterness.

Olive trees are also cultivated in the Azores, but only on two islands – Terceira and Pico – and not on a large scale. The olives were traditionally grown so that their oil could be used for canning tuna and sardines, but they are now more frequently cured and sold as eating olives. It is a traditional industry and the number of growers is diminishing, but the olive trees themselves are remarkably beautiful with the greyness of their leaves enhanced by blue hydrangeas and blue agapanthus in the summer months.

France

L'olivier, cet arbre mythique

Est vraiment magnifique ;

Il paraît magique, fantastique, féerique…

C'est un drôle de loustic !

[Jean Giono (*Poème de l'olive*)]

Olive trees were brought to southern France by the Phoenicians and planted more widely when the coastal regions came under Greek control. In Roman times, which coincided with a period of warmer temperatures, they supplied oil to Rome.

Olives, however, are only of marginal cultivability in France. They must contend with the cold dry gales of the *mistral* and they fall victim to prolonged periods of cold weather. Older olive-growers recall the great frosts of 1956, when the damage was such that they needed financial help from the government in Paris and lobbied successfully for the system of name-protection and territorial recognition – the ancestor of today's PDOs – to be applied to olive oil, like wine, as *appellations d'origine protégée*.

Most olive-owners are little more than 'hobby farmers' who belong to a local cooperative that helps and advises them on the best cultivation practices. Larger plantations do exist, but nothing to match the scale of olive orchards in most of the Mediterranean. Some of the best – Château de Montfrin in Gard, for example, and Château de Calissanne in Bouches-du-Rhône – have substantial areas of olives within a much larger wine estate. Nevertheless, there is a multitude of small owners growing innumerable local olive varieties that have been enshrined in eight small *appellations* with evocative names like 'Olives noires de Nyons' and 'Huile d'olive de la vallée des Baux-de-Provence'. The *appellations* also extend to olives: cracked green olives, for example, are a speciality of the Baux valley.

The industry is small and fragmented, with an average annual oil production of 5,000 tonnes However, French consumers buy an average of 110,000 tonnes of olive oil per year. And, since the French are generally convinced that everything French is better than anything foreign, the prices at which French olives and olive oils are sold are absurdly high.

Today, the economic importance of France's olive trees is insignificant, but their landscapes have been praised and painted for centuries. Together with the dark Italian cypress trees, they symbolise the beauty of

France's Mediterranean coast. Claude Monet, Edgar Degas and Henri Matisse, all painters reared in northern France, were enchanted by the play of light on the shapes and colours of the olive trees that they saw in Provence. When the Dutchman Vincent van Gogh wrote to his brother from Saint-Rémy-de-Provence in 1889 about the problem of catching the unique beauty of olive trees, he confessed:

> "I am struggling to capture the light... it is silvery, sometimes bluish, sometimes greenish, whitish, on a yellow, pink, violet or orange to red ochre background. It's very difficult..."

Even today, it is hard to think of the countryside around Menton or Les Baux without recalling how much they contribute to the beauty of their situation.

But the whole area is redolent of Provençal character and culture. Jean Giono, whose writings so often celebrate the unique nature of the region, lived in Manosque in the Alpes-de-Haute-Provence department. A little way up the valley of the River Durance is an olive-growing village called Les Mées, whose parish church is dedicated to Notre Dame des Oliviers. Here the valley is edged by spectacular cliffs made of conglomerate and known as Les Pénitents to commemorate the monks who were turned to stone for eyeing a procession of beautiful Saracen women. And, incredibly, the olives are still cultivated by monks today.

The Adriatic Coast:
Slovenia, Croatia, Montenegro, Albania

The Dinaric karst limestone of the eastern Adriatic coast is perfect for olive-growing. Oil from Istria was famous in Roman times and olives have flourished there and in the Illyrian islands ever since. The Venetians planted and cultivated olives trees during their centuries of occupation but olive-growing was neglected during the communist 20th century. Today, Slovenia and Croatia have a flourishing industry, with high-quality oils that win international prizes. Croatia has six PDOs, based on individual islands and their indigenous cultivars – for example, the dual-purpose Oblica olive on the island of Brač, Plominka and Slivnjaca on Cres, and Lastovka and Drobnica on Korčula. The trees are old and quantities are small, but there are now substantial new plantings of traditional varieties, as well as imported Italian cultivars. In some islands, such as Sipan, traditionally the father had to plant thirty new olive trees when a son or daughter got married.

There are also ancient olive groves along the coast of Montenegro. Two of the trees claim to be more than 2,000 years old – one at Mirovica, and the other at Mrkojevići, both near Bar. The dominant olive is Žutica, an old cultivar that makes excellent oil if picked young and pressed without delay.

Albania, too, has a long history of olive-growing; archaeological sites have revealed oil mills dating back to the fourth century BC. It also has a high consumption of eating olives. New plantings of olive trees, in response to tax incentives, have been made all over the country in recent years, especially in the southern prefectures of Berat, Fier and Vlora. There is a tradition in Albania that a bride's veil is blessed by a crown of olive twigs to wish her happiness and prosperity. This may be a relic from the early Ottoman years when every wedding was, by law, commemorated by the planting of ten olive trees.

Turkey

Turkey acquired most of its olive trees after its war with Greece in 1922. Under Ottoman rule, the landowners were Turks, but the farmers and entrepreneurs who ran the flourishing olive-oil industry were Greek. Olives had been planted for thousands of years around the coast of Turkey but especially along the Aegean seaboard, the southern coast and in the Arabic-speaking province of Hatay. There were also plantations that remain today along the Black Sea coast in such areas as modern Sinop, Samsun and Trabzon.

Today, the leading olive-growing provinces are Aydın, Izmir, Muğla, Balıkesir, Manisa and Bursa. Some 400 olive cultivars are thought to grow in Turkey, though fewer than half are recognised by the Ministry of Agriculture. Thirty cultivars are widely grown, including Ayvalık (Edremit)in the north and Memecik in the south, mainly for olive oil. The black table olive varieties are Uslu, Edincik Su and, especially, Gemlik, while the green table olives (often stuffed) are Domat and Yamalak Sarısı. Dual-purpose Halhali is the main cultivar in Hatay. Some 119 named cultivars are known in Turkey, all cultivated in the Bornova Olive Research Station near Izmir, which has been endorsed by the International Olive Council as its third collection of cultivars.

In much of the country, Turkish olive-growing is still very traditional. Three-quarters of the olive trees grow on rocky slopes and receive little by way of fertilisers or irrigation. It is no surprise, therefore, that the average olive yield is very low – some 11.7 kg per tree, compared to 50 kg in Italy. Some new plantings have

however been made on ground that is flat or only slightly sloping, especially around Izmir, Aydın, and Manisa. And irrigation has increased significantly in recent years, drawing on reservoirs and lakes such as Iznik and Marmara. The trees are often old – their average age is reckoned to be about 75 years – and large, which makes harvesting difficult. Much is done by hand or with sticks.

Turkey's Ministry of Agriculture has encouraged an increase in olive planting, coupled with improved management, pressing and storage facilities. The number of olive trees has more than doubled since 2002 and there has been a significant growth in exports, especially by successful brands and individual estates. Another part of the Turkish government's agricultural policy has been to encourage greater home consumption of both olive oil and table olives. This, too, has been a success, not least because people have become more health conscious, more knowledgeable about olive oil and more interested in the qualities of the individual olive cultivars.

The European Parliament accepts applications for Protected Designations (PDO) from countries outside the EU and Turkish olive oil now has three: Milas, Edremit and Aydın Memecik. Others are expected to be added in the future. These are a good mark of progress in quality. At present, however, the United States is the leading importer of Turkish olive oil followed by Spain (for blending) and Japan (individually packaged).

Private investors are modernising every aspect of Turkey's olive industry. The typical operators have little or no land of their own so first they need to acquire the olives. They go from village to village to meet farmers and explain what they can offer for top-quality olives. They also explain their conditions of contract. These insist upon good cultivation, usually organic, early harvesting and the use of machines instead of traditional sticks to collect the olives, which must be placed in crates instead of sacks and delivered to the mill within four hours. The mill will have state-of-the-art fast-working extractors, capable of transforming up to 70 tonnes of olives each day. Each batch will be tested for its composition and assessed for its taste. Stainless steel storage tanks will be used to separate the oils according to their quality. The operators hope to retain the farmers' loyalty in future years by advising them on how to improve the quality and quantity of their crop and by keeping them informed of market conditions. Some producers now sell monovarietal extra virgin olive oils of the Memecik or the Ayvalik variety, for which they make higher payments to the farmer. Likewise, in the market for table olives, a premium is paid for large, top-quality Domat or Gemlik olives. These varieties are now so valuable that they have begun to be cultivated outside their natural areas.

The modernisation of the olive industry has brought many changes for the best, though one might be permitted to regret some of the alterations that the government's policies have brought to the beauty of the

countryside. But mechanised pruning and harvesting have improved production, and many more trees produce better oil and better olives as a result of feeding and watering.

Turkey is especially known for olive oil wrestling, a traditional sport that days back at least to 1346. It has for long been a popular sport all over the country but the national championships take place every July at Edirne and have certainly been an annual event since 1362. The *Guinness Book of World Records* endorses it as the world's oldest sporting competition. Wrestlers wear lightweight leather breeches and cover their bodies in oil, which makes it hard for them to grab one other. There are rules, of course, and a wrestler loses the contest if his back or his elbows touch the ground, or if he sits down with his hands behind him. Three tonnes of olive oil are used over the course of the three-day event, which makes it an expensive sport – not least because the economy of Turkey has for many years been ravaged by high rates of inflation.

A generational tree more than 1,700 years old,
the Peset Celma family, Traiguera, Castellón (Spain)

Montserrat,
Barcelona (Spain)

La Vilella Baixa,
Priorat, Tarragona
(Spain)

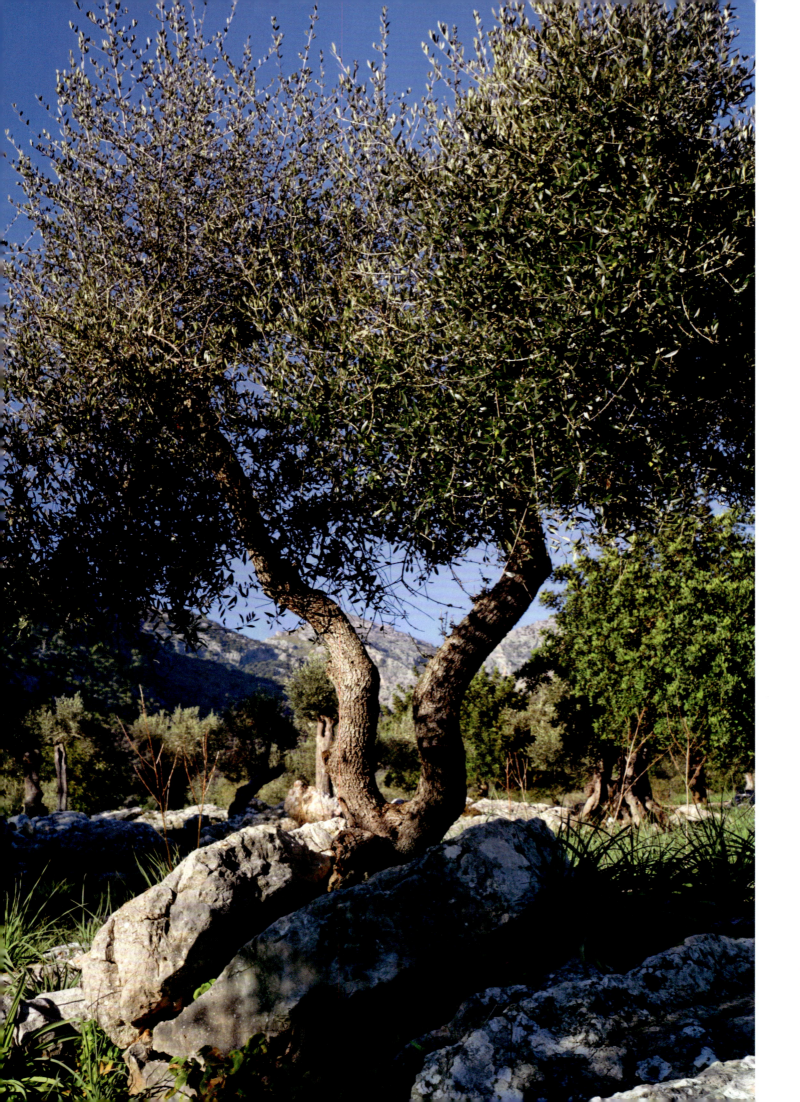

A fighter of
an olive tree,
Sierra de
Tramontana,
Majorca (Spain)

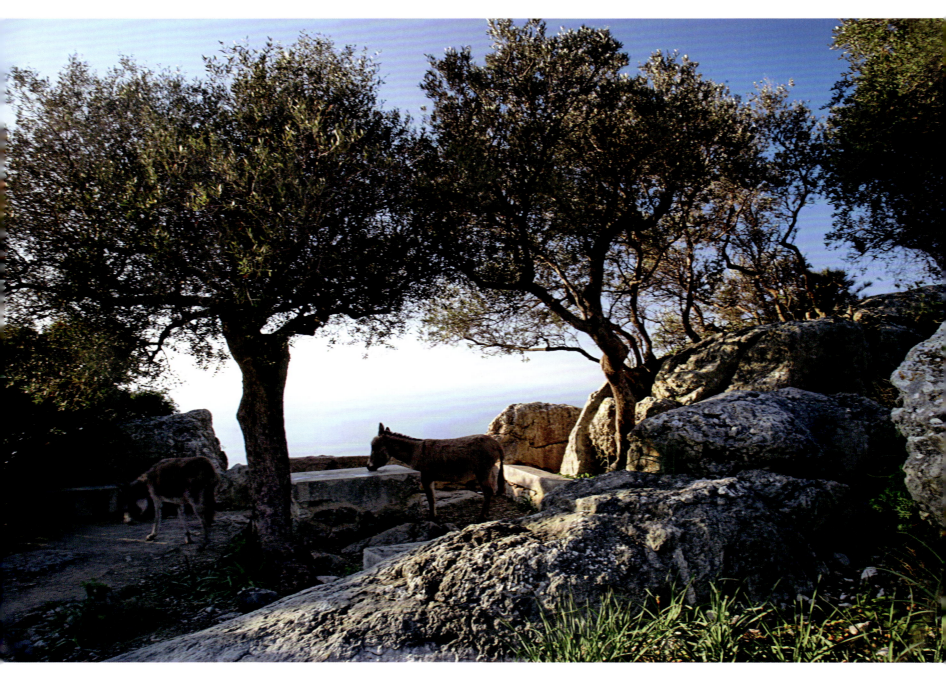

Olive trees, donkeys
and the Mediterranean,
Majorca (Spain)

Day breaks over the sea of olive trees, Úbeda, Jaén (Spain)

Next pages:

Peña de los Enamorados, Antequera, Málaga (Spain)

Shaking olive trees, Guijo de Santa Bárbara,
Cáceres (Spain)

Wood on the fire,
La Vera, Cáceres (Spain)

Sierra de Las Villuercas, Cáceres (Spain)

Next pages:

Valdelageve, Salamanca (Spain)

**Mallos de Riglos, Huesca
(Spain)**

**Flood irrigation, Belchite,
Zaragoza (Spain)**

The most northerly
olive trees in Europe,
Lake Garda (Italy)

Biodynamic farming,
Lucca, Tuscany (Italy)

Olive trees creeping
low to combat the wind,
Pantelleria Island (Italy)

Whitewashed
olive trees
to repel insects,
Puglia (Italy)

Temple in Agrigento, Sicily (Italy)

Giants, Paxos Island
(Greece)

**Olive trees bathing in the Mediterranean,
Paxos Island Greece)**

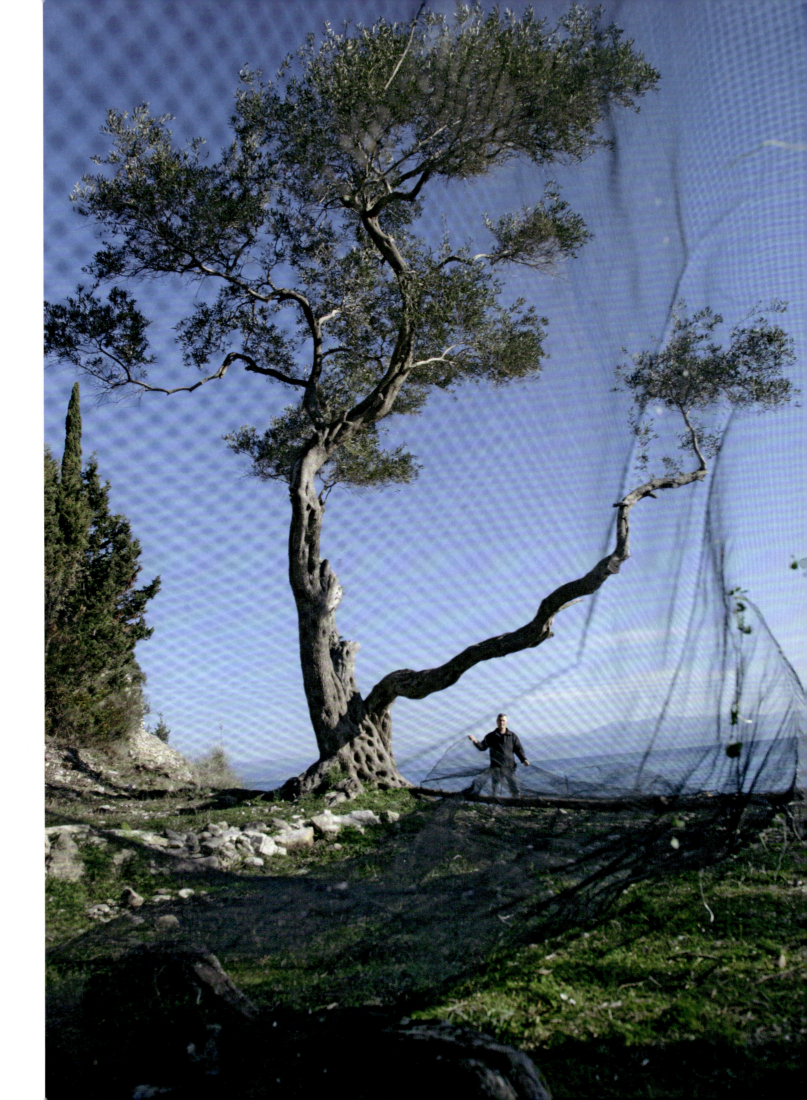

Nets to catch
olives, Paxos
Island (Greece)

Cretan landscape
(Greece)

**Minoan Palace of Knossos,
Crete (Greece)**

**Different ways of growing olive trees,
Crete (Greece)**

Olive trees marking the
boundaries between country
estates, Alto Duero (Portugal)

Vines and olive trees,
World Heritage landscape,
Alto Douro (Portugal)

Terceira Island, Azores
(Portugal)

Glory in his
hands, Rochers
des Pénitents,
Provence (France)

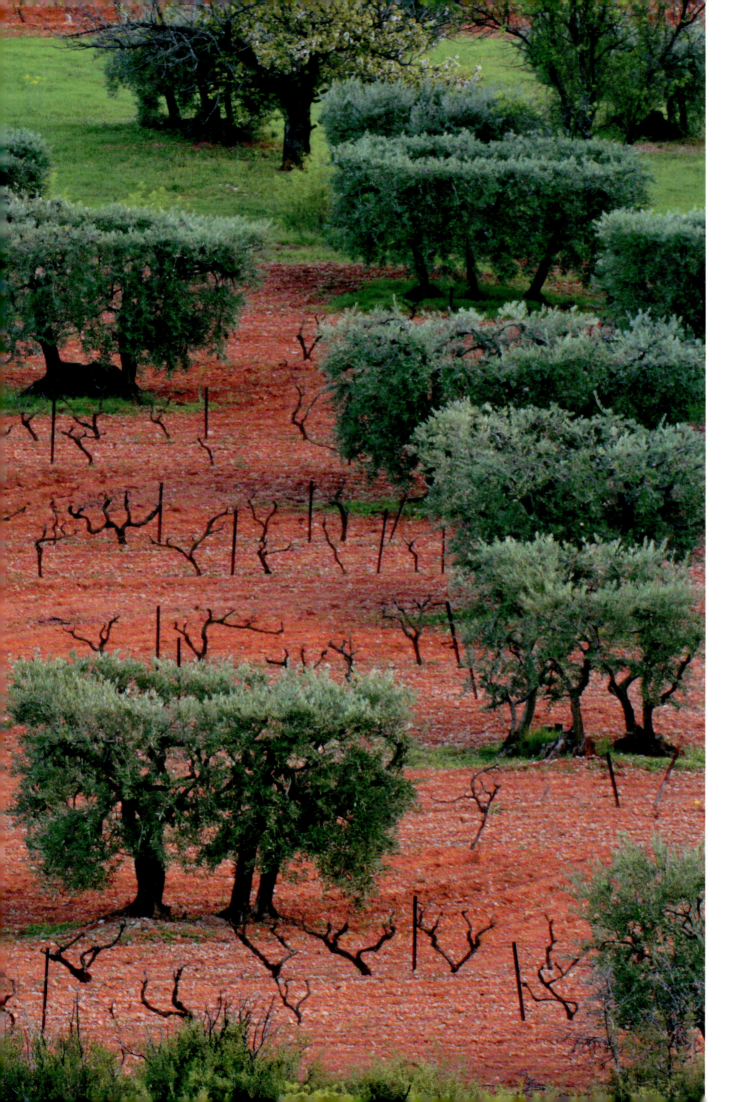

Topiary design olive
trees, Provence (France)

Andrea Cantore Badurina hangs a trap for the olive fruit fly.

The traveller returned to his grandparents' home to look after
these ancient olive trees, Pag Island (Croatia)

Wild olive trees grafted sometime after
the 19th century and growing in between the
rocks, Pag island (Croatia)

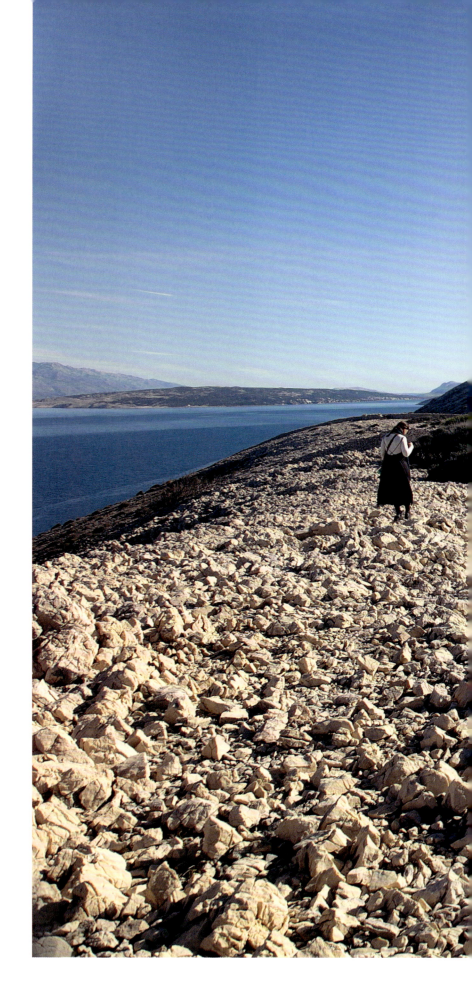

On the eastern side of Pag Island (Croatia) no plants grow due to the salty wind that lashes it. Life springs forth on the western side

The 2,500-year-old Albanian giant can hold up to 30 people and produces 1,500 kilos of olives a year, Palikesht (Albania)

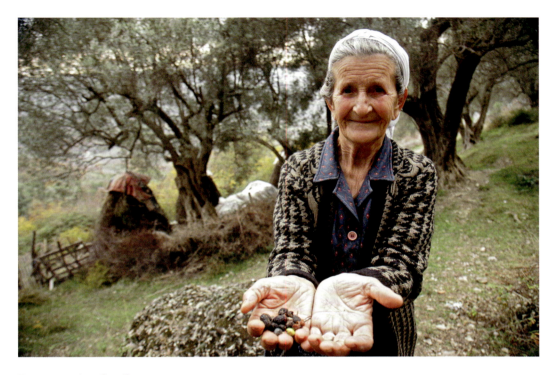

**Every tree is a family treasure,
Petrela (Albania)**

**Olive groves planted in bunkers,
Borsh (Albania)**

The olive groves in this country
are a family experience, Preza (Albania)

Ephesus (Turkey)

Ruins in Ephesus (Turkey)

Next pages:

**Olive trees in Teos, Ionia (Turkey).
Some will have seen Tales de Mileto
walking through here.**

Olives trees have graced the southern and eastern coasts of the Mediterranean for 3,000 years. Their olives and their oil are important foods. Every country where olive trees flourish would like to extend their cultivation to make use of marginal land, improve standards and greatly increase its production of olive oil to sell to Europe and North America. The problem is that the nations of North Africa and the Near East are characterised by inert bureaucracy, political instability (leading, in some cases to civil war), corruption, inadequate investment and governmental interference. All are net importers of food. Some, like Libya, are even net importers of olive oil. And Egypt, the greatest producer of table olives, is also a net importer of them.

And yet, olive-planting has increased substantially over the last 100-200 years. All through North Africa and the Near East, it was encouraged by colonial powers and is central to government policies today. Olives are widely grown in Morocco, Tunisia and Syria, but they also flourish along the coasts of Libya, Egypt and Palestine wherever there is sufficient rain. Rainfall is higher in Morocco, where olive trees will grow at 1,500 m, than in Egypt, where few will survive without irrigation. The hills of Algeria, Tunisia and Cyrenaica are usually well supplied by rain and in parts of Tunisia it is hard to believe how thickly olives are planted, how well they are grown and how they dominate the landscape. The Near East, Lebanon and western Syria enjoy a Mediterranean climate that is perfect for their cultivation.

Olives began to spread along the coast of North Africa in 1,000-800 BC, brought by Phoenician navigators, merchants and settlers. Later, the Roman Province of Africa was developed as an olive oil-producing region to supply the Empire. Emperors encouraged farmers to establish olive orchards on uncultivated land and replace old groves with new ones. Rome gave tax incentives to olive growers and built substantial irrigation systems to increase production. Archaeologists are still finding Roman olive presses of every size throughout Mediterranean Africa, even in deep southern regions that have now turned to desert.

Roman olive oil came from Volubilis, near modern Meknès, the areas around Tangier and Larache, modern Algeria's Kabylia region and the ports of Tunisia. For Africa's principal areas of production, the olive oil trade was a source of wealth. And so it is today.

Throughout North Africa and the Near East, olive-growing is governed by traditional practices. In Syria, 80% of land holdings are small, typically of five hectares and mixed with tree fruits, wheat and market gardening. More than 95% are rain-fed. Work is usually done by hand, not by machines but by women who undertake the pruning, manuring and picking. Fertilisers and pesticides are unavailable. Pests and diseases go unchecked. Irrigation is seldom available. Traditional old groves are characterised by low density, unmanaged trees and low yields.

All the nations of North Africa and the Near East would like to modernise their farming sector. They dream of well-irrigated, super-intensive, export-oriented farms, dedicated to the production of olive oil. They seek to establish intensive irrigated plantations and rain-fed groves wherever possible. Sometimes this is difficult for governments to achieve. Money may be allocated, but never get through. Private investors may be put off by the insecurities of political and economic life.

Education is crucial to the development of olive farming. Young farmers need training, backed by technical institutes, testing laboratories, modern processing plants and agricultural research centres. It is believed that this new agricultural middle class will improve every aspect of olive cultivation, bring it into line with European expectations and then create and satisfy a demand for high quality. When they have begun to produce oils that are of good quality, these emerging nations send samples to international competitions in countries like Sweden and Japan, where the culture of olive oil is not profound, in the hope of being awarded a medal. That medal then becomes part of their sales pitch.

All governments in North Africa and the Near East have their eyes on exporting this high-quality olive oil to Europe and North America. But exports everywhere depend on supply and demand. At present, the olive trees' tendency towards alternate-year cropping makes regular sales difficult to guarantee. In a year of abundance, large volumes of surplus olive oil are available for export to the EU and the US. But those surpluses may be difficult to sell if the harvest has also been plentiful in Europe or South America, which competes for the North American markets.

Some countries have already been successful. Morocco is a major supplier of agricultural products to Europe, including olives and olive oil. Some 30% of the table olives produced in modern processing plants are consumed locally; the rest is exported. Tunisia has established close links with the European Union and enjoys preferential tariffs for its olive oil. Imports are free of duty up to a certain level, which Tunisia is always keen to increase.

Tunisia is the North African country that others should copy. It is the most northerly of African nations, on the same latitude as southern Sicily, which produces some of the best of all olive oils. So does Tunisia, but its oils are relegated to topping up the blends that are sold all over the world by large European companies. Olive oil is Tunisia's principal agricultural export and the scale of its olive plantations – 1.8 million hectares and 86 million olive trees – is exceeded only by Spain. More than 75% of its olive oil production is export-oriented, primarily to the European Union.

These successes have inspired other nations. Egypt produces more table olives than any other country. 95% of its olive crop is oriented towards that sector. Some are exported but more still are imported; Egypt has a

population of 110 million to feed and 95% of the nation's surface is desert. And yet the government's plan to plant 100 million olive trees is designed to produce oil only partly for home consumption, but more especially for export.

Egypt is not the only country to believe that by greening its deserts with irrigated olive-growing it will be able to boost its acquisition of hard currency. Libya aims to plant 20 million olive trees, supported by state-run or state-licensed nurseries for raising young plants. These, too, are a feature of every planned economy in North Africa. And the annual production of young olive tree plants in Syria is about five million, of which 60% is produced in state nurseries and sold at very low prices.

All through North Africa, urban growth and the promotion of intensive, export-oriented agriculture have put increasing pressure on tribal and collective lands. The governments argue that new activities are necessary to generate jobs and income, and to promote the emergence of an agricultural middle class. New olive trees are part of the equation. In Morocco, for example, 15 million hectares – a little less than a quarter of Morocco – belong to Berbers. The government considers these collective lands, currently put to nomadic animal-rearing, to be poorly managed and unproductive. Morocco's latest plan for agriculture requires forced nationalisation – expropriation and redistribution among well-educated young farmers supported by government loans. Most of the land is suitable for olive-growing. When governments justify the destruction of a traditional agro-ecosystem, they emphasise the importance of protecting their natural resources. But this does not mean conservation of the environment or of traditional lifestyles; 'natural resources' means land that they consider suitable for more intensive cultivation.

The nations of North Africa and the Near East are rich in olive cultivars unknown in Europe. Some 90% of all olives in Morocco are of the Picholine Marocaine variety. It has no connection with the French Picholine olives but is an excellent dual-purpose choice for traditional olive-growing – high-yielding, hardy and drought-resistant. Rather to everyone's surprise, DNA testing has found Picholine Marocaine to be identical to the Mission olive of California. An effort has been made to increase the use of other indigenous Moroccan cultivars, including Meslala and Bouchouk, but it is difficult to show that they have an advantage over improved forms of polyclonal Picholine Marocaine like Menara and Haouzia. Picholine Marocaine is also grown under the name of Sigoise in the Tell Atlas region where it occupies 25% of the Algerian olive orchard. Chemlal – not to be confused with Tunisian Chemlali – predominates in the Kabylia region, east of Algiers, and accounts for 40% of the Algerian olive groves. Recent tests have identified 36 varieties of olive trees endemic to Algeria, including Takesrit and Azeradj, but a further 55 varieties are soon to be added to the national catalogue. The Soummam Valley, right at the eastern end of the Atlas Mountains, is an area of exceptional olive biodiversity.

Tunisia has a flourishing olive industry and Tunisians extol the virtues of their two leading olive varieties: Chetoui in the north and Chemlali, which accounts for some 75% of Tunisian oil, in the centre and south. Still further south, dual-purpose Oueslati, Gerboui and Sayali have a strong presence, as do a multitude of table olive cultivars, including Meski and Tounsi. In the arid region of Tataouine, the desert climate means that olive trees can only be grown if they are planted in depressions to obtain the maximum available water. Here, the promising indigenous cultivars include Fakhari, Dhokar and Zarrazi. When grown not in the desert but further north, all of them make good quality oil with a fine, fruity taste.

The selection of cultivars for table olives is more important in North Africa than in Europe. Market barrows piled high with their glistening olives are a must-see tourist attraction from Marrakesh to Cairo. Some 80% of Libya's olive plantations, mainly in Cyrenaica, are committed to table olives. Table olives are important for Egypt's food industry and grow wherever they can be established – around Alexandria, on the Mediterranean coast and in north-east Sinai, close to the frontier with Gaza. Some intensive plantations have recently been established on irrigated land inland from Moghra, and in the deserts surrounding Cairo and Menia. The best-known cultivars, all traditional olives, are picked over a period of six to eight weeks, starting with Toffahi (large, picked green in late August) and followed by Aggezi Shami (also large, and picked when green in mid-September), and Aksai (best described as a slightly smaller Aggezi Shami, picked late in September). Egypt's newest plantings – a planned 100 million irrigated trees – are in the area between Alexandria and Cairo, a large area west of Minya on the River Nile, and inland from Matrouh on the northern coast. The government subsidises the acquisition of young olive trees from licensed nurseries, and ensures that their cultivation is supervised by national agricultural research centres.

Ethiopia is the only country between Egypt and South Africa where olives may be cultivated to a high standard, but they remain almost unknown. However, the native African *Olea europaea* subsp. *cuspidata* is often planted near churches, including Abyssinia's sunken rock-hewn churches, because of its importance to Christian tradition. It is also valued for its hard wood, which is widely used for such varied purposes as home-made toothbrushes and goads for driving domestic animals. Traditional medicine-practitioners believe that wild olives help in the treatment of malaria, cold sores and high blood pressure.

In Lebanon, Israel, Palestine and Jordan, the most widely grown olive in unirrigated land is the traditional Souri cultivar. It is often grown alongside Nabali, another dual-purpose variety, as a pollinator, though recent experiments show that Arbequina from distant Spain is even more effective and results in larger crops. Syria has many local cultivars, each restricted to a different area, including oil-producing Zaity in Aleppo, dual-purpose Sorani in Idleb and Khoderi in Latakia, Doebli in Tartous, and Dan in Damascus. Olives are a bigger market in Syria than oil; Kaissy is the most widely grown local cultivar.

Rasi'i is widespread in Jordan because it can be grown in mountainous areas with an annual rainfall of around 330 mm. Israel has many olive cultivars from Europe, including Picual, Leccino and Coratina but, like Lebanon, it is a net importer of both oil and olives. Israeli olive oil is high in quality but low in volume.

Israel has bred new cultivars like Barnea and Askal. In Morocco, crosses between Picholine Marocaine and foreign varieties have brought five new cultivars into production: Agdal, Baraka, Dalia, Mechkate and Tassaoute. Moroccan scientists have also selected a clone of Picholine Marocaine called M26 which produces oils with a more complex and harmonious taste. Egypt also has a Genetic Improvement of Olives Project which involves crossing local varieties with foreign cultivars in the hope of breeding new hybrids that produce a larger crop of higher quality fruit. Local cultivars grown for their table olives, including Aggezi Shami and Toffahi, have been hybridised not just with leading European table-olive cultivars, notably Kalamata and Manzanillo, but also with modern oil-producing clones of Koroneiki and Arbequina. Egypt hopes to raise new cultivars that are suitable for high-density or even super high-density cultivation under Egyptian conditions.

Syria is a major olive-growing power. It has a large home market, where the annual per capita consumption is between five and seven kilos of oil, with considerable potential for expansion. But, for a while, political problems, including the civil war, impacted on government control and private sector investment. Now, the government offers loans to establish new olive orchards or to upgrade existing groves, to install irrigation and to import modern machinery. An Olive Bureau, backed by new educational institutes, has been set up as a specialist centre for carrying out research and for encouraging olive growers to adopt modern techniques. Olive growing is concentrated in the north and west – Aleppo, Idlib, Latakia, Damascus and Dar'a – where some 30% of the production is of extra virgin olive oil, most of which is exported in bulk to Europe.

Lebanon generally has a moderate Mediterranean climate and is blessed with plentiful supplies of water that allow olive trees to grow and flourish. The principal olives in Lebanon are local varieties with such names as Baladi, Ayrouni, Smoukmoki and Souri. The traditional dual-purpose variety putatively named Baladi is predominant in the old Lebanese olive groves. But, being a very old cultivar, it is represented by selected clones: a recent DNA analysis of 60 olive trees of Baladi showed up 45 distinct genetic profiles. And the name Baladi, meaning 'local', is commonly used by farmers to indicate any nameless variety, including clones and different genotypes.

Olive-farmers throughout the Mediterranean are concerned about climate change, though they are sometimes too quick to mistake bad weather for long-term changes. The summers are getting hotter.

There is insufficient rain in winter. In 2021, wildfires devastated Tizi Ouzou, a highly productive olive-growing province in Algeria's Kabylia region. In Egypt, summer temperatures are rising, rainfall is dwindling, and the winter season is proving too warm for olive trees to set the flower buds that will eventually turn into olives. Drought threatens more than 8 million olive trees in Libya; farmers complain about the government's failure to support them, but the Libyan Ministry of Agriculture is short of funding. Drought leads to desertification.

Combating desertification is part of every North African nation's programme for agriculture – and managing its water resources is always an essential part. Plans for intensive olive cultivation in pre-Saharan areas is always backed by promises of better irrigation.

Most of the countries of North Africa and the Near East have expansive hinterlands of empty desert – empty, that is, apart from oases. These oases are hotspots of biodiversity, with hundreds of different palm trees and a great number of distinctive olive trees. A survey of the Degache oasis in Tunisia revealed 37 distinct olive cultivars. Eight were close to existing Tunisian cultivars and could be considered as local variants – clones not found elsewhere. The remaining 29 cultivars could not be matched and can be regarded as putative new cultivars. At Palmyra in Syria, some 19 unique cultivars were known in 2000, including Abou-Satl and Tadmor, but modern farmers are quickly replacing them with 'better' varieties. And one of the most remote and fascinating places in Egypt is the Siwa oasis, an area about 80 kms in length and 50 kms in width in the west of the Egyptian desert. Because it lies below sea level (though 350 kms from the Mediterranean coast) it is watered by innumerable springs. Olives have been cultivated at Siwa since at least 500 BC. It has a unique assortment of indigenous olive cultivars – Hamed, Maraqi and Wattagen, as well as Siwee. The trees are cultivated in a very traditional manner and their oil is not, by modern standards, of good quality, but there is romance attached to being offered an olive oil so ancient and distinct.

**In the Atlas Mountains
(Morroco)**

Time stands still, Taroudant (Morroco)

"The donkey has taken ill...,
so it's my turn to do it",
Chenini (Tunisia)

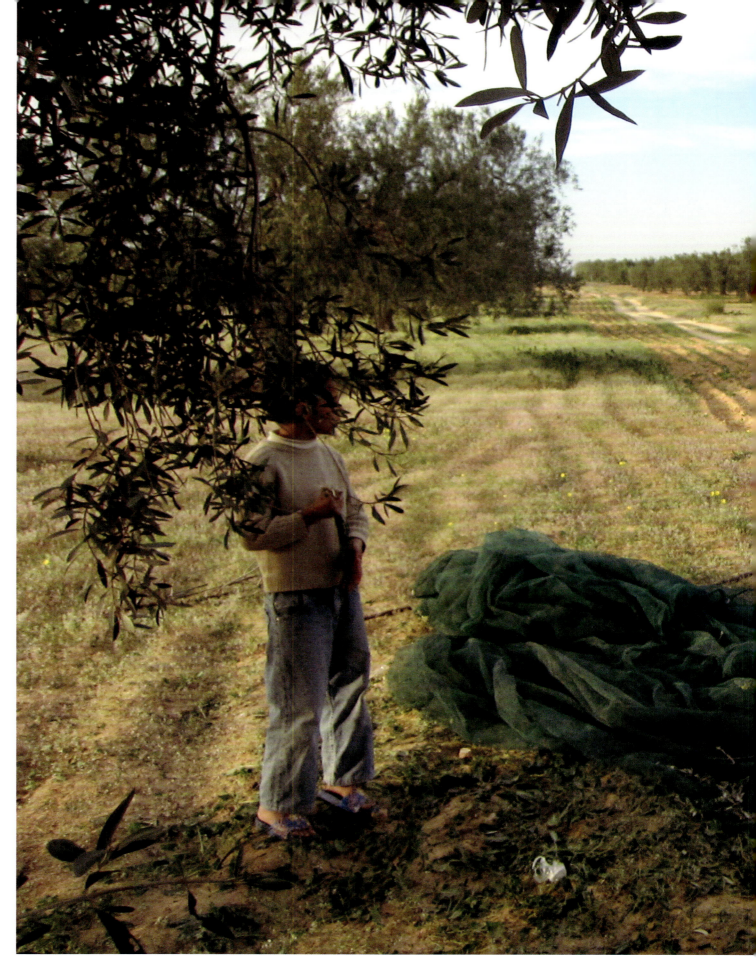

The family with
the dancing mother,
Sfax (Tunisia)

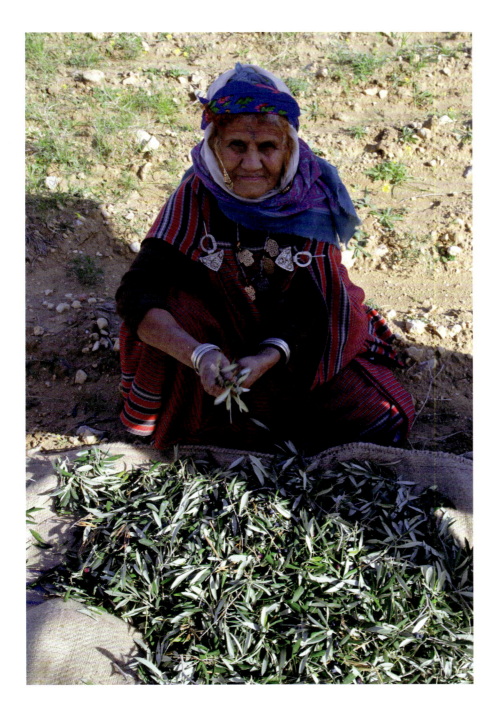

Separating out the
leaves from the olives,
Zaghouan (Tunisia)

The little olive tree, like a treasure, fighting against all odds, The Sahara (Tunisia)

Next pages:

Catching olives up high, Siwa Oasis (Egypt)

**Tree nursery near
Cairo (Egypt)**

Olive trees near Cairo (Egypt),
irrigated with underground
fossil water

The olive tree, symbol
of Christianity,
Lalibela (Ethiopia)

Giant olive trees pointing
the way to the churches,
Lalibela (Ethiopia)

**Missionary praying among
the olive trees in the Garden
of Gethsemane, Jerusalem (Israel)**

Next pages:

**Palestinian tending his
treasures, Beerseba (Israel)**

Palmira (Syria)

Local farmer protects his olive
tree from the wind and livestock,
Euphrates River (Syria)

Ancient Phoenician olive press,
Smar Jbeil (Lebanon)

Syrian refugees working
in a Lebanese olive mill,
Bechmizzine (Lebanon)

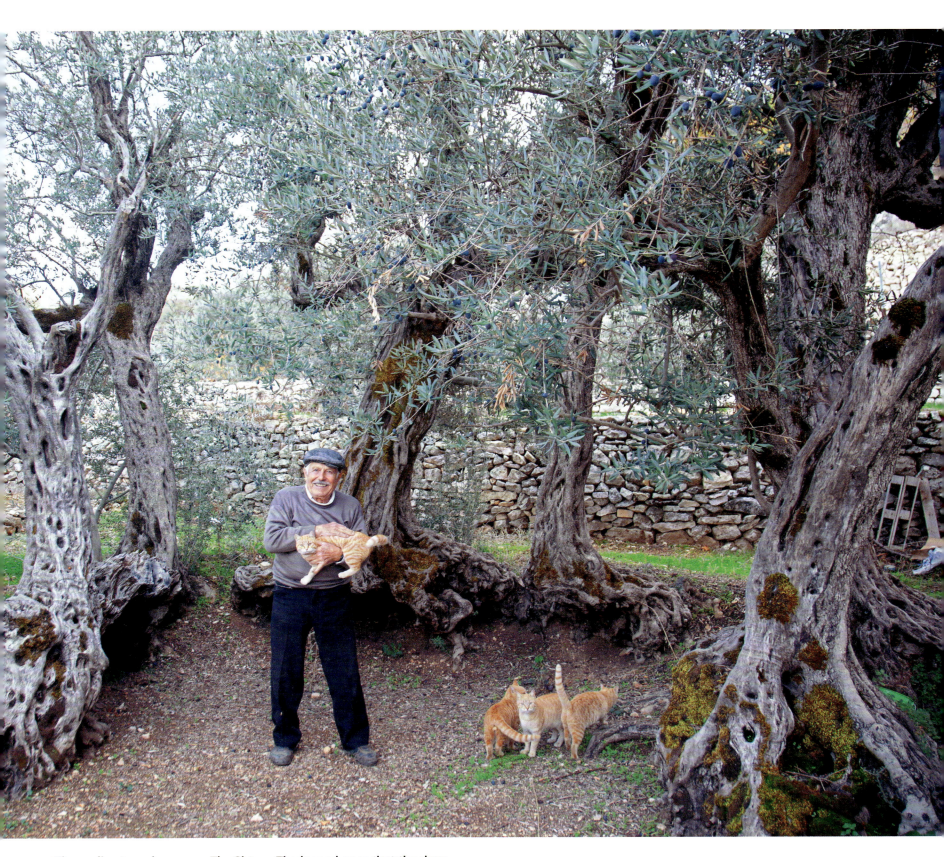

Three olive trees known as *The Sisters*. The legend goes that the dove plucked a branch from these olive trees and brought it back to Noah. They are thought to be 6,000 years old, Bechealeh (Lebanon)

Druze and Syrian
workers harvesting
olives, Hasbaya
(Lebanon)

Asia

Olive trees were first domesticated in the Near East. Their cultivation then spread west around the Mediterranean and eastwards into Asia. They are grown in small quantities in Iraq and Afghanistan, and rather more widely in Iran. Extensive new plantings have begun in Pakistan and India. Japan has grown olives since the 1860s and China since the 1960s. All these nations also import olive oil from around the world.

Iran

Olive-growing expanded eastwards after its domestication to the Zagros mountains, the shores of the Caspian Sea, the mountains of Iran's Kerman province and east towards Baluchistan. The provinces of Gilan and Qazvin are the most important for Iranian olive production today, as well as Golestan (also adjoining the Caspian Sea) and Khuzestan, deep in the south-west of the country at the head of the Persian Gulf. The soils and climates of the areas where olive trees survive in Iran show the most extreme differences: the habitats range from average winter temperatures of -7°C in Kerman, altitudes of up to 2,500 m, average summer temperatures of 46°C in Hormozgan and an annual rainfall of less than 300 mm in much of the country. Close to the Caspian Sea, however, the annual rainfall is 1,000 mm, which means that irrigation is available there – but not in other regions.

The three most common Iranian cultivars are Golooleh and Shengeh (for table olives) and Rowghani (for oil) – all unknown to western growers and scientists – but there are endemics also in the south, of which the most widely grown is just known as Hormazeitoon. Most Iranian cultivars are table olives – they account for 70% of olive groves – and some are said to produce larger fruits than the Mediterranean Gordal Sevillana. Until recently, olive oil was used only for soap manufacture. Since Iran's olive cultivars have developed in isolation, with no contact with Mediterranean germplasm, scientists regard them as a most promising source of new options for breeding and the future welfare of the olive as a cultivated plant.

Saudi Arabia

The country whose recent involvement in olive growing surpasses all other nations is Saudi Arabia. Government-backed investment there has led to the creation of extensive olive plantations in the north of the country, near the border with Jordan. The first olives at Al-Jouf were planted in 2007; by 2018, the Guinness Book of Records acknowledged it to be the biggest planted area in the world. At that point, it had 5 million olive trees grown over 7,730 hectares – figures that have greatly increased since then. Some 20 million trees are now thought to be growing in the region and cultivation is also expanding in Ha'il and Tabuk. Visitors to these vast plantings find that the rows stretch so far into the distance that they seem to have no end. Cultivation is completely mechanised. Picking and pruning are undertaken by high-density harvesters. Irrigation is essential and water is automatically distributed directly to each tree.

Most of Saudi Arabia's new plantations are high-density or super-intensive. Spanish cultivars are popular, especially Arbequina and, more recently, Arbosana. Almost 80% of the Kingdom's olive cultivation is geared toward olive oil production and the remaining 20% – a relatively high proportion – to table olives. Some 30 different varieties from France, Spain, Italy, Greece and Turkey are grown in Saudi Arabia. Government-sponsored trials are run to establish which cultivars suit the unusual climatic conditions. Picual and Manzanilla, both dual-purpose olives from Spain, have proved themselves, as have the traditional Middle-Eastern varieties Sorani and Nibali.

The desert is conquered, Al Jouf (Saudi Arabia)

India and Pakistan

The story of olive-growing in India and Pakistan is recent. Interest focuses on the increasing popularity of table olives as foodstuffs and the importance of olive oil for health – notably the fashionable Mediterranean or Cretan Diet. Working with Italian experts, Pakistan agronomists realised that the Potwar plateau in the Punjab, previously somewhat deforested and degraded, had a suitable climate and could be revived by the introduction of olive-growing. Trials of table olives showed particular success with Ascolana, Gemlik and the little-known Earlik and Hamdi cultivars; the best for oil included Arbequina, Coratina, Leccino, Chemlali and Ottobratica, plus two hybrids locally developed by the Barani Agricultural Research Institute at Chakwal and released as BARI Zaitoon 1 & 2. Inevitably, there is talk of creating a sustainable olive oil economy with an export-oriented industry that will also benefit the rural communities of the region. But this is backed up by extensive new annual plantings, typically of 600,000 young olives.

India also realised that its part of the Punjab – and parts of Rajasthan – are suitable for olive-growing and works with Israeli experts. And it was from Israel that the first plantings were made of Barnea, Frantoio, Arbequina, Cortina, Koroneiki, Picholine and Picual. The trees are grown in intensive or super-intensive plantations, and the industry has economic support from national and regional governments. Indian consumption of olive oil, most of it imported from Spain and Italy, is increasing at an annual rate of 30%, partly (it is said) due to campaigns like 'Olive it Up'. It should also be said that foreign companies are investing in Indian olive-growing and that other parts of India are also suitable for olive-growing. There is oil production now in Uttar Pradesh, Himachal Pradesh and the region known as Jammu and Kashmir. The fact that olives are tolerant of poor and marginal soils also assists the Indian government's aim to increase the income of farmers everywhere and develop a more prosperous agrarian middle class. The market potential is enormous.

China

During the Cold War years, China had a close political alliance with Albania. One curious outcome of this relationship was that 1,500 plants of Albania's endemic olive cultivar Kaninjot were exported to China to kick-start Chinese olive-growing. Today, the industry is posited on a taste among China's well-to-do for extra virgin olive oil and its association with a healthier lifestyle. As in other countries, this has stimulated demand.

Today, the prefecture of Longnan in Gansu claims to be the largest producer in China, though a challenge may soon by mounted by the area around Xichang in Sichuan. Both areas have the perfect 'Mediterranean climate'. Within Longnan, it appears that the largest producer is Xiangyu Olive Development Co, which is a small enterprise by European standards but manages its marketing, publicity and sales very well. It says that it has trialled 100 olive cultivars, but its oil comes mainly from Leccino, Koroneiki, Pendolino, Picual and Picholine, as well as Chinese varieties Ezhi-8 and Gheng'Gu-32. Another company in Longnan, called Shanghai Olive Light Biotechnology, sells an Ezhi-8 monovarietal oil with the name Whispering Flowers. It won an award at New York's Olive Oil Competition in 2022 and 2023. However, when Xiangyu won a prize at a competition in Greece in 2020, the oil was said to have been made from Coratina.

Xiangyu and its associates cultivate 42,000 hectares. One year, its output reached 5,700 tonnes, equivalent to 85% of the total in China. Enormous energy and effort are put into its marketing and presentation. The retailing of its products is stylish, too. Although it is difficult for westerners to get a true overview of the state of the olive industry in China, there is no doubt that it will expand and, perhaps, emerge one day as a major player in the international market.

Japan

Olives were first introduced to Japan from France in 1862. Oil was first made at Mita in Kobe province in 1881 and was popular in the early 20th century as hair-oil. In 1908, however, 1,000 ha of Mission olive-trees, were planted on the island of Shōdo, principally to provide a source of olive oil for the expanding sardine-canning industry. Now, however, Shōdoshima, the second largest island in the Seto Inland Sea, is known as the Olive Island and has become a tourist attraction.

Shōdoshima's Mission olives are late-harvested, when they are ripe. Their oil is soft and smooth, but not very exciting. Quality is now improving, but the island is probably better known among the Japanese for its olive-oil sweets. New cultivars have recently been introduced from Europe, including Picual and Lucques. And there is a second Japanese olive grove at Ushimado in Okayama prefecture, opposite Shōdoshima. Its olive-trees came from Greece.

Trials of other olive cultivars – Carolea, Koroneiki, Picual, Leccino, Frantoio – are in progress in other parts of Japan. Some of the trials are tests of hardiness in such prefectures as Miyagi, Fukushima and Gunma – and even in Hokkaido. Landholdings in Japan are small and sometimes they are abandoned. The thinking is that some of them might be converted to olive-growing.

**Woman in a forest of olive
trees, Taleqan (Iran)**

Street stall, Taleqan (Iran)

Street stall, Taleqan (Iran)

Next pages:
**Farmer showing us the way to his olive
grove, Al-Jouf Region (Saudi Arabia)**

Traditional
olive-growing,
Al-Jouf Region
(Saudi Arabia)

One year-old
olive tree already
producing olives,
Al-Jouf Region
(Saudi Arabia)

Modernity in the biggest olive tree plantation
in the world, Al-Jouf Region (Saudi Arabia)

Previous pages:

**New territories,
Jaipur (India)**

Jaipur (India)

Standardized Nursery Area

Our standardized nursery can propagate 1 million high quality stocks in a 30 mu production area. All pruning will begin in mid March and the cutting will be propagated in the high temperature canopy and moved the rooted cutting to a soil based container in May and transplanted the following March.

The olive tree in a monsoon climate, Shichuan (China)

Next pages:
Shichuan (China)

New Worlds

South America

Tradition tells us the first olive trees in South America – three of them – were brought to Lima, either directly from Spain or via Mexico, by Don Antonio de Rivera in 1560. By the end of the 16th century, olive trees were cultivated in Peru, Chile and Argentina. Most of the early olive plantings were for landowners who valued table olives or for missionaries in need of olive oil for sacramental purposes. There is a plantation at San Isidro near Lima, for example, that is associated with the Dominican saint Martín de Porres.

Some of these old olive groves are still flourishing. In Arica and Atacama, the well-watered valleys have olive trees known to date from the 17th century. There are few sights more exhilarating than that of standing high on a bare, desert mountainside in Chile or Peru, looking down on a bright green oasis where olive trees provide shelter for more intensive market-gardening. Traditional olive-growing is still important, socially and culturally, throughout South America. Administrators, settlers and, later on, the masses of immigrants from Europe, brought a rich assortment of olive cultivars from Europe.

One of the most successful introductions is a big, fat olive known as Arauco in Argentina, Criolla in Peru and Azapa in Chile. Argentinians claim that Arauco is uniquely Argentine in its origin and that Chileans and Peruvians stole cuttings of the original tree. Recent DNA testing has shown that all three are clones of Gordal Sevillana, introduced from Spain in the 16th century.

Like many young nations with European origins, the Spanish American republics are keen to conserve relics of colonial rule that have aesthetic value or historical importance. There is a 400-year-old tree of the Arauco cultivar, still growing near the town of that name, which the Argentines have declared a national monument. It was declared a 'national historic tree' in 1946 because it was the only "plant that remained alive from the felling that King Carlos III ordered" and declared a National Historical Monument in 1980.

That felling of olive trees never happened, but the myth survives that the king ordered the destruction of all olive trees in Spanish America, and most especially the provinces that would eventually become Argentina. He did so because he "feared that the prosperity of olive-growing in the area might eventually exceed olive production in Spain." No record has ever been found of such an order, though the legend tells us much about the resentments sometimes felt by colonial Argentina towards its imperial masters in Spain. There is now an international organisation called Sudoliva which encourages Spanish American governments to

conserve old olive trees. Its database includes more than 50 centenarians, many of them associated with historic sites, including Mexico's Tláhuac Heritage olive tree, which was probably planted by the missionary Martín de Valencia.

In parts of Chile, Argentina and Uruguay, the recent story of olives is similar to that of many countries in the southern hemisphere – lifestyle plantings attached to wine-producing estates, alongside large-scale, irrigated, super-intensive plantations.

These modern plantations have completely changed the scale of production and are driven by international demand. Governments gave tax incentives to encourage investment in large commercial enterprises, usually with high densities and drip irrigation. Irrigation is key to their success – super-intensive plantations of Arbequina trees grown for their dependable yield – but it has to be sustainable, which many are not. Many of the recent plantings have been made in areas of very low rainfall or, even, in irrigated deserts. Some are in climates that would appear not to be suitable for olive-growing. And others have been planted at altitudes and latitudes unknown in Europe. South America is therefore proving to be a crucible of new experiences in olive-growing.

It follows that a corpus of wisdom is building up in South America that may alter the way olives are grown in other parts of the world. For example, the Italian variety Frantoio, which needs winter chilling to flower and fruit, now grows and sets fruit in the coastal deserts of Peru, where the winter temperatures drop no lower than 10°C. Agronomists do not know whether this is an effect of the cold Humboldt Current or because the constant cloud cover in winter compensates for insufficient chilling. Nor is it known why olive trees flourish in parts of Argentina's Córdoba Province where most of the rain falls in the summer and none in winter. And Arbequina, the most common cultivar in super-high-density orchards, is behaving atypically: it flowers consistently, even in warm subtropical regions, but its oil content is much lower than in the Mediterranean.

South America is certainly an exciting continent for olive-farmers, and for growers of many other crops. Parts are bedevilled by political corruption, administrative incompetence and inflation so rampant that prices must be agreed and paid in US dollars. But the worldwide demand for table olives and, especially, for olive oil, is growing so fast that investors continue to expand their interests in olive trees. The strange anomaly is that all this production is oriented towards the export of olive oil. In Uruguay, less than 1% of olive production is destined for table olives. Home consumption is minimal – typically 300 ml per capita. The main market is Brazil, which has few olive trees of its own because the only area with a suitable climate is the southern state of Rio Grande do Sul, close to the Uruguay border. Half the population of

South America lives in Brazil and 40% of its oil imports come from Portugal – mainly soft oils from Galle-ga olives. But Brazil is a good market for Chile and, especially, for Argentina, always in need of hard currency. The South Americans are also building up exports to the United States and China and, when – as happened in 2022 and 2023 – its own stocks run low, Spain looks to South America to fill the bottles it sells to European supermarkets.

North America

Mexico is the only country to include olive trees in its National Anthem:

> *Ciña ¡Oh Patria! tus sienes de oliva*
> *de la paz el arcángel divino,*
> *que en el cielo tu eterno destino*
> *por el dedo de Dios se escribió.*

The first olive trees were brought to Mexico in 1531, by Fray Martín de Valencia. These were the variety Mission, which is known as Picholine Marocaine in Morocco and Cañivano Blanco in Seville, from where it came. And there are modern plantations in the Mexican states of Tamaulipas and Sonora, which hope to benefit from increasing demand for olive oil in the United States.

During the 18th and early 19th centuries, Spanish Franciscans worked their way up the coast of California and founded missions from San Diego de Alcalá to Sonoma. The Mission olive trees they took with them – a source of sacramental oil – were the foundation of America's olive industry today.

Mission is a dual-purpose cultivar and, in 1898, a German widow living at Oakland invented the method of preserving firm, black olives in tins. This is a uniquely American way of treating table olives that has now been copied in parts of Europe.

The United States is an important importer of olives and olive oils from Mediterranean countries and South America, but it is not a significant producer. Olives are grown in Arizona, Florida, Georgia, Oregon and Texas – and all have potential for success – but it is California, the state with a truly Mediterranean

climate, that dominates the emerging olive industry in North America today. Nevertheless, California accounts for a tiny fraction, perhaps 2%, of all the olive oil consumed in the United States today. The problem is that California cannot compete consistently with the best oils from Italy and Spain, whether on quality or on price.

Small-scale olive groves were planted throughout the 20th century and some have been adapted to make olive oil (of variable quality) for the 'gourmet' market. Olive-growing is also promoted as a symbol of California lifestyle which, in turn, is a metaphor for the Mediterranean lifestyle. Boutique producers proclaim the virtues of antioxidants, the Cretan diet and the anti-ageing properties of olive oil.

California's olive growers have not enjoyed the unpredictability of their climate. A big freeze in winter, spring temperatures too high to set the fruit, followed perhaps by drought in summer, are problems that Mediterranean farmers encounter from time to time, but have a discouraging effect on investment in the Golden State. Here, with characteristic American energy and self-belief, it should be possible to develop an industry that rivals the excellence of olive oils and table olives from Spain, Greece or Tunisia.

The future of the olive industry in California lies with the extensive super high-density plantings in much of the flat Central Valley. Here the uncertainties of the weather are less disheartening and good irrigation is always available. California Olive Ranch was one of the first operators to adopt a policy of mega-investment in the Central Valley. It is now the largest olive-oil company in North America and has put its '100% California Everyday' oil on the shelves of supermarkets all over the United States.

Australia and New Zealand

Europeans – mainly British and Irish – began to settle in Australia towards the end of the 18th century and the first olive trees were planted shortly afterwards, near Sydney. Later European immigrants from Mediterranean countries imported cultivars that they knew and grew back home in Europe. Nowadays Arbequina, Barnea, Coratina, Frantoio and Picual represent approximately 85% of the total area planted.

In one sense, the olive industry in Australia is very fragmented. There are small producers and hobby farmers in all Australian states. Some of their oils and olives are strictly for family consumption, and some are sold

in specialist food shops. The oils tend to be made from late-picked olives and are therefore mild, bland and almost sweet, with little taste of the fruit. The better ones have rather more character.

However, there was an explosion of investment in planting olive trees between 1996 and 2004, much of it driven by tax exemptions and the introduction of irrigation. The industry was said by 2022 to extend to ten million trees, grown on 450 commercial groves, covering 20,568 hectares, with 70% of olive trees concentrated across 20 substantial estates. Cobram is by far the largest operator, with intensive and super-intensive plantations around Corio on the edge of the Murray River. As a result of this investment, olive oil production in Australia has grown from over 2 million litres in 2004 to more than 20 million litres in 2021, a 'good' year. Meanwhile, consumption has also grown so fast that Australia is the largest consumer of olive oil per capita outside the Mediterranean.

Australia has strict phytosanitary rules about the transport of plants. It is the only country in the world, apart from New Zealand, where the pestilential olive fly is definitely absent. And scientists are especially aware of the potential dangers posed by the introduction of non-native plants – including olive trees. Landowners are required by law to destroy any wild olive plants they find on their property. Before these regulations became law, however, it was not unusual for enthusiasts to gather the fruit of wild olive trees and press them. The quality of the oil was inconsistent but occasionally its flavour was excellent, if unusual.

For visitors from other continents, the sight of kangaroos and emus bouncing and scurrying around an olive plantation is a surreal experience never forgotten.

New Zealand's olive industry is much smaller. Olive trees are grown all over the country but especially in North Island. Nevertheless, 90% of the oil consumed is imported, mainly from Spain. The most widely planted cultivars are Frantoio and Leccino from Tuscany and 99% of the oil is extra virgin, but it is never enough to satisfy demand.

In both Australia and New Zealand, olive trees are also sold to home-owners as features that will add value to their property. The Mediterranean dream is as strong Down Under as in California – and the promotion of olive oil as the cornerstone of the Cretan Diet is no less persuasive.

South Africa

South Africa's Western Cape has a Mediterranean climate that is perfect for growing olive trees. Jan van Riebeeck, a Dutch government administrator, planted the first trees in about 1660, but commercial olive-growing on a very limited scale did not begin until the early 1900s. The real expansion dates back no further than the 1990s, prompted by the desire of wine estates to diversify their activities and by a market demand for home-grown olive oil and olives. Wine tourism is a major industry, and olive oil complements it, as in California, Australia and New Zealand.

A very large number of olive cultivars are grown in South Africa, but especially Frantoio for oil and Mission for table olives. Favolosa, Leccino, Kalamata and forms of Manzanilla also have their supporters but there is a growing trend towards super-intensive varieties, and it is likely that Arbequina and Koroneiki will shortly be among the most numerous new plantings.

The industry is small, but planting and production are both growing fast, currently at an annual rate of 20%. Most holdings are also small, less than 5 ha. Some two million litres of olive oil are extracted each year, but the volumes are increasing. A further five or six million litres of olive oil are imported annually. In terms of table olives, around 1,400 tonnes of olives are produced, and about the same volume is imported each year. That said, South Africa already exports olive oil to neighbouring African countries, particularly Botswana and Namibia.

One of the largest holdings is Willow Creek near Worcester, which has more than 150,000 olive trees (with eight cultivars) on 200 hectares of land. Quality is very high. In addition to Willow Creek, the estates at Tokara, Morgenster, Rio Largo, De Rustica, Babylonstoren and Mardouw have all won international prizes and enjoyed some success in English-speaking markets, including the United Kingdom and the United States.

Labour in South Africa is cheap and employment is keenly sought, so many of the production processes are undertaken manually. Most estates have their own in-house systems for the preservation of olives and for extracting, storing and bottling oil. Power supplies – 'load shedding' is a daily problem – and political instability are the principal factors holding back the development of South Africa as a major participant in the market for olives and olive oils and, indeed, in other fields.

River Ilo
Valley (Peru)

Olive groves in the Atacama desert (Peru)

Parque El Olivar (Olive Grove Park)
in the San Isidro district in the centre
of Lima (Peru). The first olive tree was
planted by St. Martin de Porres
in 1637

**Olive tree planted by Jesuit missionaries circa 1700
in the San Francisco Javier Mission in Viggé-Biaundó,
Baja California (Mexico)**

Super-intensive plantation, Alonso Olive Oils,
O'Higgins (Chile)

Olives planted around 300 years ago, irrigated with water from the Andes, Atacama desert, Arica (Chile)

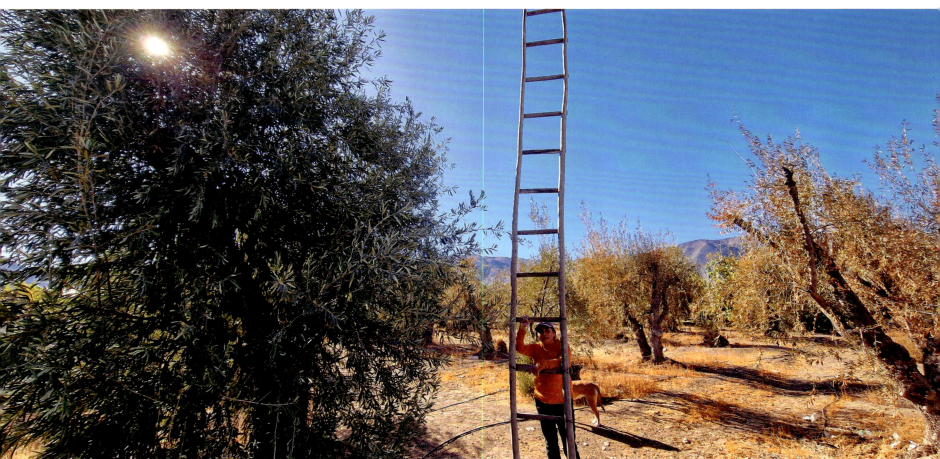

Wall covered with dry
olive branches to protect
it from erosion (Chile)

The prolonged drought
is gradually killing
off the olive grove,
Santa Filomena (Chile)

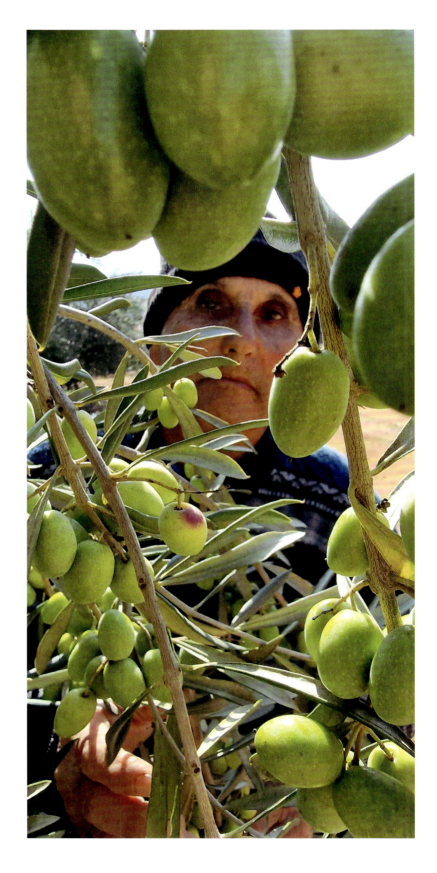

Traditional harvesting,
La Estrella (Chile)

Olive trees at a height of 1,625 metres,
with the Andes in the distance, Barreal (Argentina)

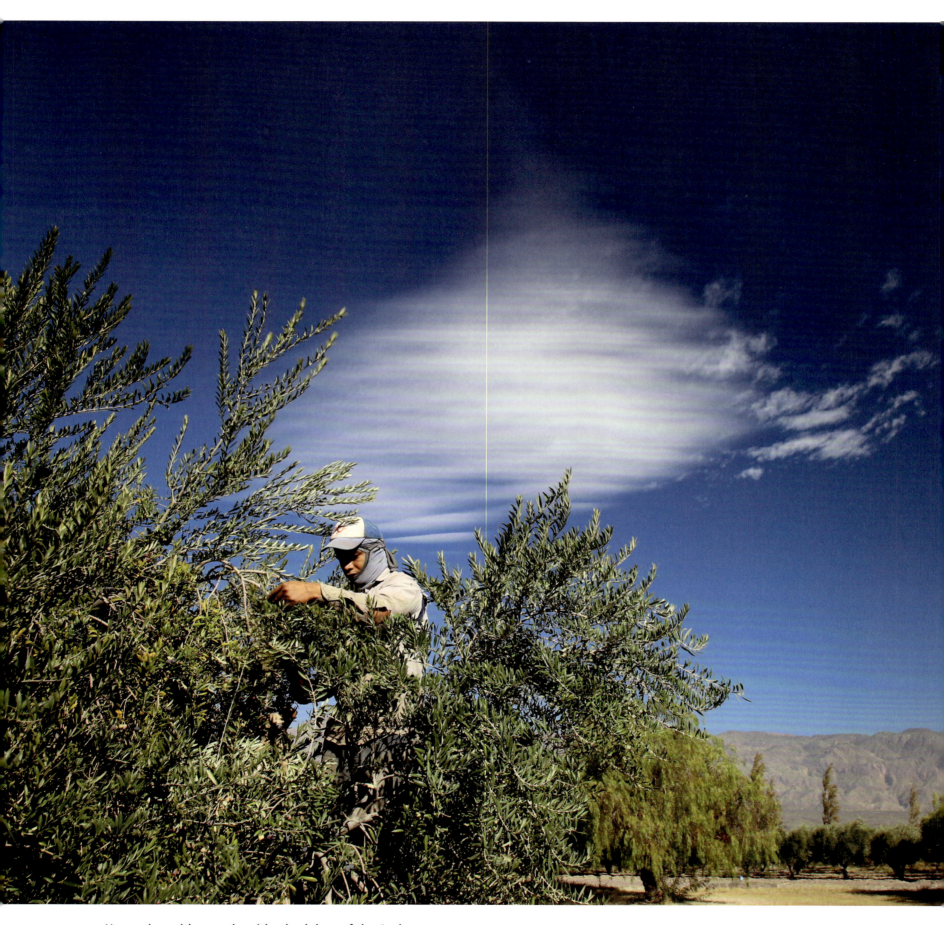

Harvesting with a comb, with a backdrop of the Andes,
Pocito, San Juan (Argentina)

Cruz del Eje (Argentina)

Zuccardi Olive Mill, Mendoza (Argentina)

Olive groves and kangaroos with the Grampians
in the distance, Victoria (Australia)

The Colossus harvester devours
the olives while the driver
stands nearby and watches
it do its work, Boundary Bend,
Victoria (Australia)

Zulu women pick olives
one by one, Stellenbosch
(South Africa)

Woman squashes the
olive onto her face as
a moisturising cream,
Stellenbosch (South Africa)

Floating...,
Stellenbosch
(South Africa)

Acknowledgments

**Roman coin from the time
of the Emperor Hadrian.**
Hispania **with an olive branch.
Casa de la Moneda Museum
(Madrid)**

Whenever you travel anywhere, it is the people who welcome you and guide you that are as or even more important to you than the country you go to. In fact, there are as many countries as there are people who show you them through their eyes, their friends, their families; each person reveals their own country through the landscapes of their soul. That is why, when on my travels, often alone, on a subject as specific as the olive tree, my trips have taken me to people like myself who have been inoculated with the passion for the olive tree and its olives. In other words, as soon as we met we were friends, even though we really didn't know each other at all. Each and every one of those people was a safe harbour, a shelter and a country in themselves.

Fifteen years is a long time. On my first trips to hunt down olive trees I stumbled around seeking coincidences, all on the basis of uncertain tips passed on to me by word of mouth. As time went by, the information began to reach me through Google and I started to make contact with people through Facebook. Anyway, it's a different world now.

In Italy, in Venice, I was given accommodation by the always open-handed and generous Manolo Morales de Jódar. In Lucca I was welcomed with *grazie* by Iñigo and Mimosa Álvarez de Toledo. On Pantelleria Island I was accompanied and guided to see the rampant olive trees by Mr and Mrs Phillis.

In Croatia, Mara Ucovic opened the doors to its beautiful islands; I owe her my glorious induction into that beautiful country. My thanks also go to Dubravco Andrijic for being so ready and willing to help. On Pag Island, Andrea's passion in caring for and saving the thousand-year-old wild olive trees was infectious. I am also grateful for the strange appearance on that island of Agnes Snieske, a cheerful girl from Iowa, USA, who was studying the relationship between man and landscape.

In Greece, on Paxos, thank you to Federico Spínola, who generously opened up his house without knowing me at all. In Crete, my hosts and guides were Lisa Radinovky and Irini Kokolaki, both of whom so kindly gave up their time for me and showed me their world.

In Turkey, my thanks go to Mehmet Hakan, a researcher on olive tree varieties, introduced to me through Facebook by Hande Yilmaz, who gave me his time and passion for Turkish olive trees. *Shukran* to both of them.

In Albania, so isolated until recently, I was fortunate to meet a professor from the University of Tirana, also an expert in olive-growing: Ilir Mehmet. Without him I would have gone astray.

In Malta, Sam Cremona showed me his white pearls or leucocarpa olives.

In Morocco, Bachir Tabchich gave me lodgings and warmth in his Taroudant palace (Palais Claudio Bravo Hotel).

In Lebanon, I found accommodation, food, a guide and laughter thanks to Christophe Gollut and the welcoming and cultured Daniele Gerges.

In Israel, thank you to Albert Salvans, a missionary who appeared in prayer in the Garden of Gethsemane. I was able to travel through the country with Moti Harari, the father of cherry tomatoes and many other things. I am grateful to him for sharing his knowledge and for giving life and food to the Turkana desert.

In Egypt, I met El Chichiny Abdelhay, with his exemplary olive grove, irrigated with fossil water. He gave me shelter in his house and shared his exciting intelligence with me. In Siwa, Abdallah -Baghri showed me his permanent smile and the prodigious olive groves in the oasis. And what can I say about the unforgettable Lola Rodríguez, that charming, generous and brave lady from Malaga who invited me to her house in the bowels of the mountain where we became friends and still are.

In China, thank you to Xavier Marqués, who flies the flag for olives by planting thousands of trees and who made my trip around that huge country so easy. And how can I not thank the great Chinese olive oil producer, Xiangyu, in Longnan, and Mrs Yuhong Iiu, for their tremendous hospitality and assistance

In Iran, I met Ramin Baktiar, an excellent guide who is now my friend.

In Saudi Arabia, Mohamed Kaltaleb was my patron and protector. My thanks also go to Saud Al Jouf and Yasser Al -Ali, from whom I learnt so much.

In Mexico, Baja California, I had an intrepid American, Christy Walton, as my home in every sense; and also a wise guide in Rodolfo Palacios.

In Peru, I met a Don Quixote who is fighting to defend the hundred-year-old olive trees in the Americas: Giancarlo Vargas. He opened doors for me in Argentina, Chile and Australia. I will be forever grateful to him.

In Argentina, I was helped by José Mustafha and Esteban Santipolo, as well as by Miguel Zuccardi, who has created such an exquisite olive-growing place in Mendoza.

Chile was a delight to be in thanks to two lucid and beautiful women: Alicia Moya and Carola Dummer. My gratitude goes to Juan José Alonso, who with talent and a lot of skill makes a great oil, and to Mario Carreno, a charming, smart friend who opened Santa Filomena to us. To the amiable and kind owner of the highland olive grove Arica-Chile, Niksa Bezmalinovic. Also, to another great fighter, Pamela Silva.

In Australia, I received board and lodgings from Steve and Linda Heyes. Their son Spencer was my driver and guide. Thank you! I am grateful to Leandro Ravetti, who let me into one of the largest estates in Australia, Cobram Estate. And, of course, to the amusing and ever cheerful Jimmy Turpin. I got help preparing that trip from Juan Manuel Molina Lamothe, who shared his good contacts with me.

In South Africa, I was fortunate to fall into the good hands of Linda Costa, who generously gave me a fabulous landing there.

And in Spain… So many people were with me on my travels! Thank you to each and every one of you.

To the late and dear poet and olive-grower José Alcalá-Zamora.

To the great communicators about olive oil through *Mercacei* y *Olivatessen*, Juan and Pandora Peñamil.

To Coro Egaña Cabeza de Vaca, for conveying her passion for this tree.

To Santiago Pozo, a fervent companion through these worlds…

To Teresa Mannera, always giving… Majorca *oliveada* with her.

To Justo Rufino and Rosa Mateo, for toiling with me to make this book possible.

To Pierre Cabarrus, the pioneer of the polytunnels in Almeria and a great host.

To Marimar de Riglos, in Huesca, for leaving her family with me so that I could take photos of them working in the olive grove.

To Rosa, owner of the olive tree-house in Gorga, Alicante, for looking after her giant so respectfully.

To Tanaira Rodríguez-Díaz, a sweet lady from the Canary Islands and oil mill virtuoso, who I came across when seeking the enormous Gorga olive tree.

To the Peset Celma family, for looking after their grandfather olive trees.

To David Esteller, who guided me on the olive tree hunt in Catalonia.

To Francisco Sánchez Rivas and his wife Steffi, in Alicante, for their project that blends agriculture and culture.

To Mónica Silvestre Tuells and Stella González Tuells, for opening doors in Ibiza.

To Pepe de la Pisa, for helping me and allowing me a garden honouring the olive tree.

To Juan Manuel Molina, from *El Arte del Olivo*, in Torreperogil, for saving olive trees by creating art from their wood, and for being so endearing.

To Pablo Ramírez Miquel, an olive-grower and a centenarian, just like his trees.

To Ana López de Letona, for her generosity.

To Javier Moro, also an olive-grower and polisher of my words.

To Juan Carlos Rubio, a wise olive expert, olive producer and much, much more. In short, a wise man.

To Luis, my IT person in Jarandilla de la Vera, ever my saviour.

To Teresa Salazar, who is light in La Vera.

To Kike Miranda, for being hope in the dark.

To Joaquín Fernández de Santaella, a passionate olive-tree lover, from a family in the olive sector and always happy to help.

To Iñigo Valdenebro, an expert on the subject, who swapped olive trees for flamenco.

To Simon Arnold and Victoria Mardon, fellow olive-grove travellers.

To Jhony Cabrer, a Bolivian who shakes olives in the groves in La Vera

To Andrés López Raya, an olive-grove farmer, seeker of new horizons and a friend.

To David Marco, who adapts the best variety of olive tree to each area.

To Dr Manuel de la Peña, a real olive oil evangelist.

To my friend Luis Martín Cabiedes, son of an olive producer, for being there with his advice and friendship.

To César Canomanuel, my soulmate and rock throughout so many years, my other psychologist.

To Monty Don, who looked at my olive tree garden so attentively and passionately.

To Pelayo and to Gaspar Mencos Bojstad, for driving me, accompanying me, shaping me… and, above all, for being my sons.

To the people who backed me to find funding: José Falgás, Diego Prado and Cristian Rojas. And to the people who pointed me in the right direction in the end: Marta García-Corona and Antonio Carrasco, from Goya España.

To the editorial team: Mariana Gasset and María José Subiela, for being rigorous, attentive and warm.

To Gonzalo and Santiago Saavedra – the best publishers in the world.

To my wife Anneli Bojstad, for polishing and improving my texts and me. And above all, for always being there.

To my son León Mencos Bojstad, for forgiving me for my absences.

Lake Garda, Italy

Eduardo Mencos Valdés is a farmer, landscape designer and photographer. He divides his time between the countryside in Andalusia and in Extremadura, where he also cultivates his facet as an olive grower. He is the author of a number of books: *Mi Sevilla, La gran aventura de los indianos, Hidden Gardens of Spain, Great Gardens of Spain, Royal Gardens of Spain, Jardines, la belleza cautiva* and *Spain in Light and Shadow*. His photographs have been published in countless media including *National Geographic, Gardens Illustrated, Vogue, Elle Deco and Architectural Digest*.

Charles Quest-Ritson is an English historian, writer, journalist, editor and translator but perhaps best-known for his column in *Country Life*, the UK's leading lifestyle magazine. His books include *The English Garden Abroad, Gardens of Germany,* and *The RHS Encyclopaedia of Roses and Olive Oil,* which is still the outstanding English-language guide to olive oils from all over the world. Charles was the first Englishman to qualify as a taster of olive oil at l'Organizzazione Nazionale Assaggiatori Olio di Oliva at Imperia in Italy.

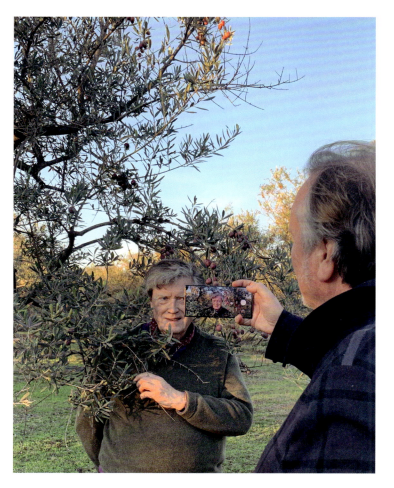

Eduardo Mencos photographing Charles Quest-Ritson Jarandilla de la Vera, (Spain)

Photographs: Eduardo Mencos

Texts: Charles Quest-Ritson

Production: Ediciones El Viso

Coordination: Mariana Gasset

Traslation and copy editing: Claire Godfray

Design: Subiela Bernat

Typesetting: Ana Martín de la Casa

Color separation: Lucam

Printing and Binding: Printer Trento

Cover: Jaén (Spain)

Page 2: Olive trees shaped by time and the wind, Sierra
de Tramontana, Majorca (Spain)

Pages 68-69: Jaén (Spain)

Pages 146-147: Gateway to the desert, Taroudant
(Morroco)

Pages 178-179: Taleqan Dam Reservoir

Pages 202-203: Olive trees with chili peppers drying
in the distance, Tacna (Perú)

Back cover: Ibiza (Spain)